CUBA JOURNEYS

CHARLES FIELDS

EDITED BY ROWLAND SCHERMAN
ESSAY BY POET OMAR PÉREZ
ORLANDO MENDEZ MONTERO

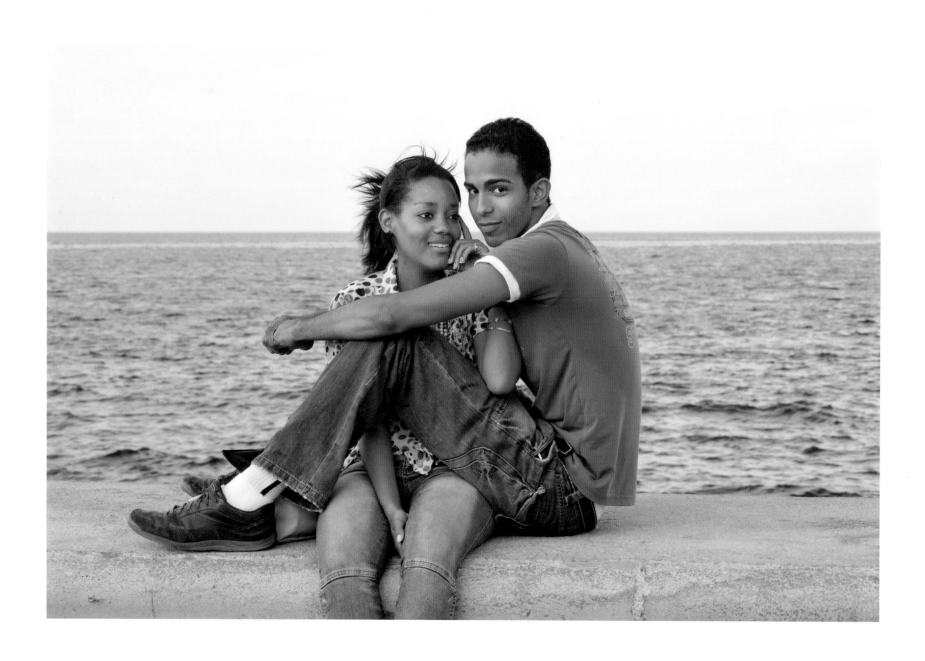

2 Couple on the Malecon, Havana

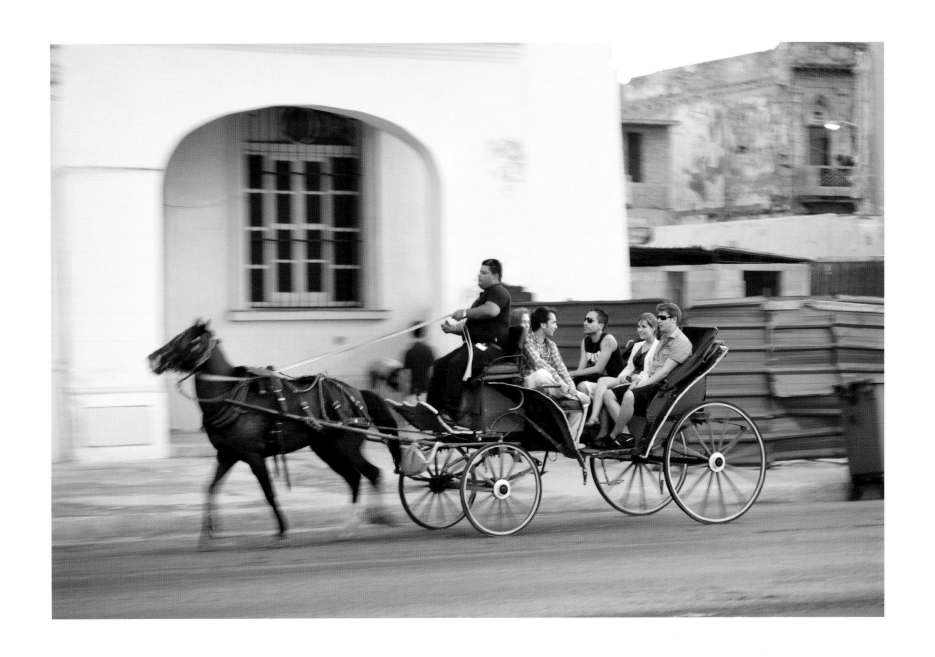

Touring Ave. Carlos M. Cespedes, Havana 3

First Edition

Library of Congress Cataloging-in-Publication Data
Fields, Charles. Cuba: photography by Charles Fields
132 pages, 10.5 x 11.5 inches
ISBN 978-0-9846186-9-9
Library of Congress Control number 2013912047
1. Cuba—Travel—Photography—Landscapes—People—Fine Art—Essay—Charles Fields—
Rowland Scherman—Omar Pérez—Orlando Mendez Montero

Photo Editor Rowland Scherman
Introduction by Rowland Scherman
Prepress Color Manager Glenn Bassett
Graphic Design Gail Fields, Richard Peal, Jim Stafford, David O. Thomas, Loreen Bosse

Office Assistant Melissa Yeaw
Essay by Omar Pérez translation by Kristin Dykstra
Essay by Orlando Mendez Montero
Captions Ileana Rodreguez, Melissa Yeaw, Gail Fields, Loreen Bosse

∞ This book is printed on acid-free paper meeting the requirements of
the American National Standard for Permanence of Paper for Printed Library Materials.

Printed in Korea

LightShip
PUBLISHING

Cuba Journeys is also available as an ebook.
LightShip Publishing is an imprint of Fields Publishing, publishers of Fine Art and Photography books and winner of the 2007 Benjamin Franklin Award
Best Art Book "Anne Packard", 2009 Benjamin Franklin Award nominee Best Coffee Table Book "Himalayan Portfolios: Journeys of the Imagination",
2009 Banff Mountain Book Festival nominee Best Mountain Image Book "Himalayan Portfolios:
Journeys of the Imagination" and 2012 Benjamin Franklin Award Best Travel Book "Vietnam Journeys".
Fields Publishing offers quantity discounts for corporate and group sales, educational, business and sales promotions.

DISCLAIMER: The information in this book was deemed to be accurate and every effort has been made to ensure its accuracy at the time of printing. However,
accuracy of facts and material representations presented herein cannot be guaranteed. LightShip Publishing makes no representations about the information,
or opinions, as presented herein other than to state unequivocally that all information relative to the photographs contained in this book were scrupulously
researched using reliable sources.

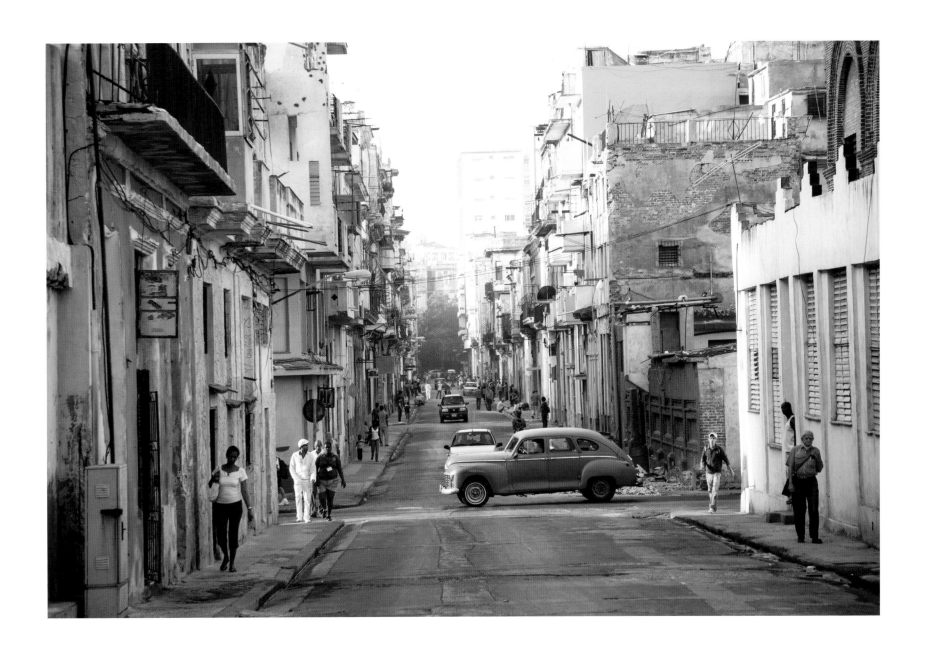

Although 2 million people are spread throughout the city of Havana, more than 150,000 of them are packed into Centro Habana, the most densely populated neighbourhood in all of Cuba.

INTRODUCTION

I had the good fortune to be asked by Charles Fields to help him edit the photographs in his book, "Cuba Journeys".

Charles didn't have to twist my arm, because when I saw the early digital "contact sheets" that he brought back from his first and second visits to Cuba, I was completely and manifestly impressed. These images, I thought, need a larger audience. Well, here they are.

I knew that the great Walker Evans had, as a young photojournalist, illustrated an important portrait of Cuba in her more troubled history. But that was in 1933. Some of Evans' pictures from that period have remained, of course, as classics.

Now it is eighty years later, and a fresh view of Cuba: post Gerado Machado, post Manuel Batista, and post a half century of Fidel Castro, is presented in this volume.

It is time to let the eye wander through a new vision of Cuba— an island nation so beautiful, so captivating, yet for decades so unjustly maligned and misunderstood. At last Cuba is seen again by a mature photographer whose work has consistently shown an uncompromising excellence of technical skill, as well as an innate gift of composition and sense of the moment.

I am proud indeed to have lent some of my vision to this project.

—Rowland Scherman, *Photo Editor*

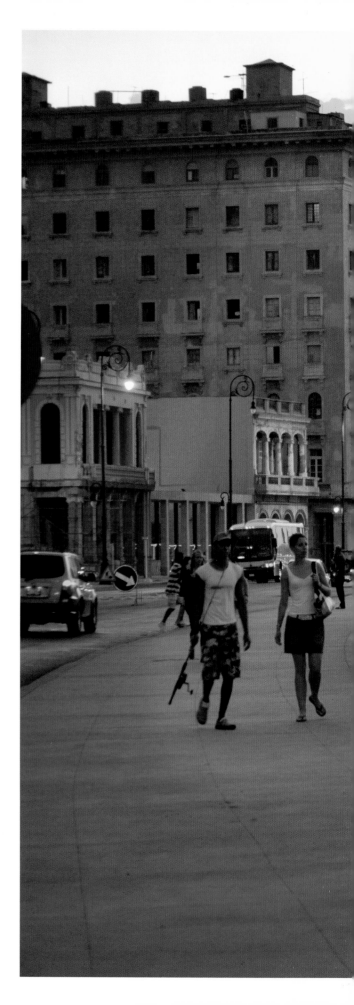

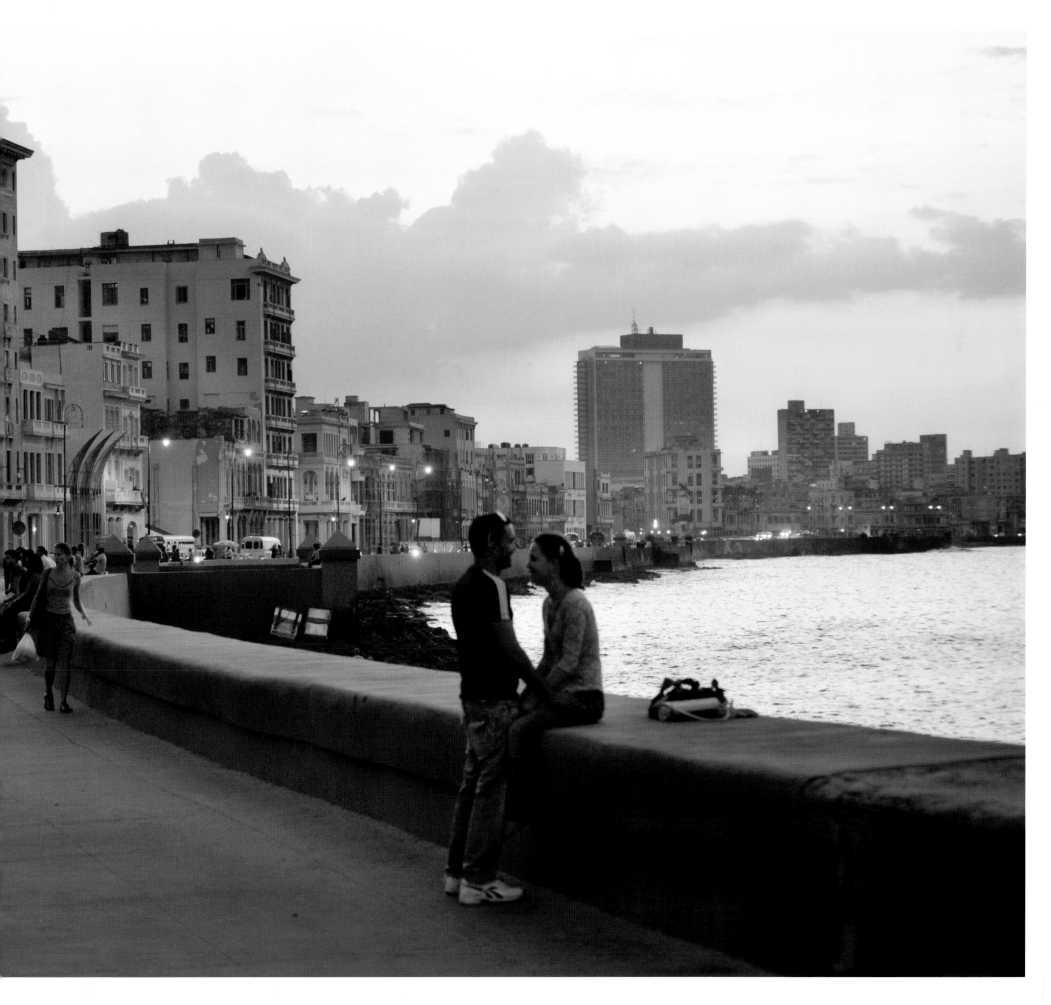

FORWARD

Cuba: it's a complex country—and a place I always wanted to go. Photography, for me, is a journey as well as an art form, an exploration as well as self expression; so going to Cuba was a self-assignment, a reason to get involved. For nine weeks, over a span of two years, I did just that. I stayed with revolutionaries, met other visual artists, and I met everyday people. I was invited into their lives, their events, their country.

I visited the studio of the famous abstract painter Wayacon, photographing him and the vivid images he was creating. For three weeks I traveled with the all-star band "Interactivo," listening to Cuban jazz fusion music and seeing the countryside, with a soundtrack!

Cubans are a proud people. They've kept their music, culture, language, their Latino thinking, and rich traditional history alive. Generously, they shared all these things with me. I tried to capture that Cuban spirit that they so willingly revealed. I am fortunate to have had this experience, and I hope that their unique culture emerges in these rich images that I found everywhere in Cuba.

This book is dedicated to Cuban people everywhere.

—Charles Fields

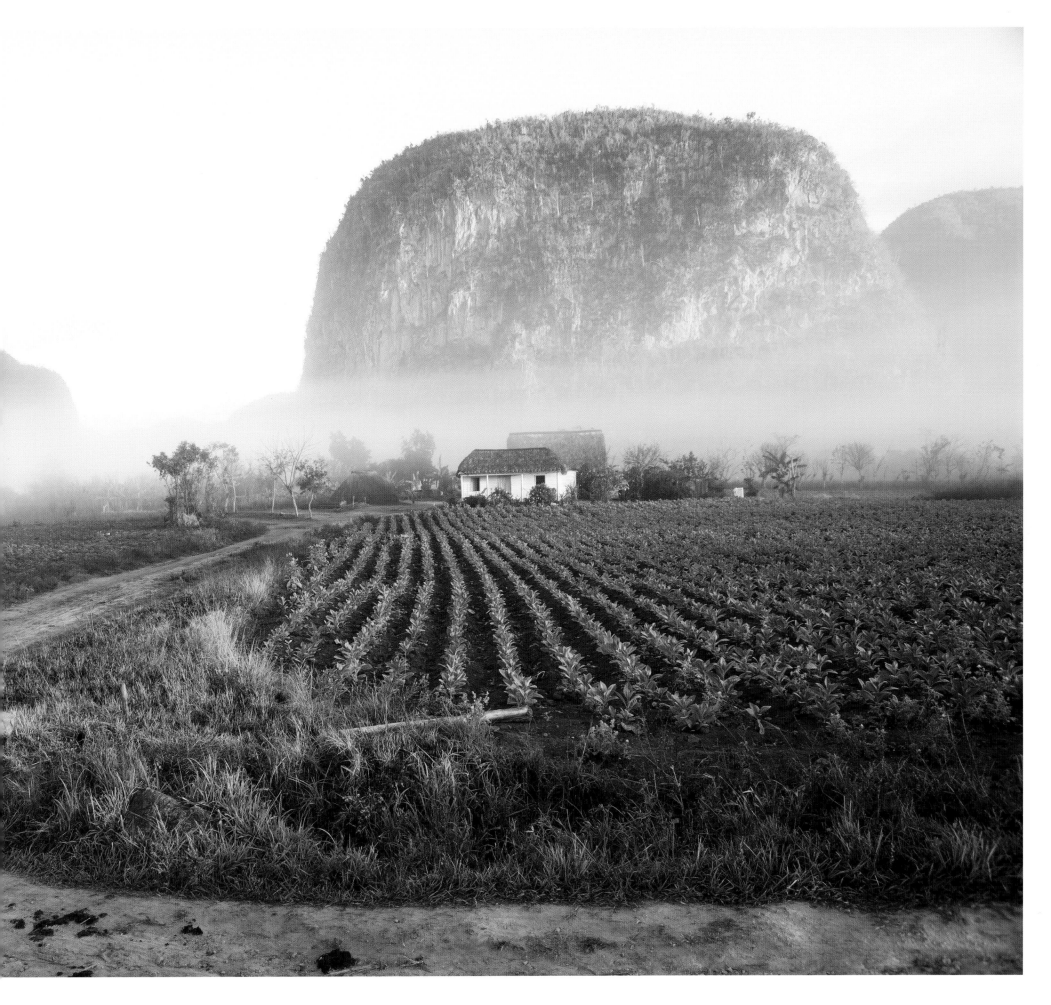

Cuba

The Republic of Cuba is an island country in the Caribbean. It comprises the main island of Cuba, the Isla de la Juventud, and several archipelagos. Havana is the capital of Cuba and its largest city. The second largest city is Santiago de Cuba. To the north of Cuba lies the United States (93 mi away) and the Bahamas are to the northeast, Mexico is to the west (130 mi away), the Cayman Islands and Jamaica are to the south, and Haiti and the Dominican Republic are to the southeast.

Cuba's history reflects a rich diverse traditional culture. The largest island in the Caribbean, Cuba was inhabited by the aboriginal Taino and Ciboney peoples prior to the landing of Christopher Columbus in 1492, who claimed it for the Kingdom of Spain. It was then colonized by the Spaniards for nearly four hundred years, after which it was briefly administered by the United States until gaining nominal independence in 1902.

The fragile republic endured increasingly radical politics and social strife, and despite efforts to strengthen its democratic system, Cuba came under the dictatorship of former president Fulgencio Batista in 1952. Growing unrest and instability led to Batista's ousting in January 1959 by the July 26 movement, which afterwards established a new socialist administration under the leadership of Fidel Castro. Since 1965, the country has been governed as a single-party state by the Communist Party.

With over 11 million inhabitants, it is the second-most populous country in the Caribbean. Independent and proud, it's a multi-ethnic country, its people, culture, and customs derived from diverse origins.

They're proud of their socialism, and look at each other as brother and comrade, regardless of racial lines. Cuba ranks high in metrics of health and education. There are more physicians per person than anywhere else in the world, and these skilled highly-trained doctors are often sent to other countries to teach their excellent craft.

The Cuban state adheres to socialist principles in organizing its largely state-controlled planned economy. Most of the means of production are owned and run by the government and most of the labor force is employed by the state.

Recent years have seen a trend toward more private sector employment. By 2006, public sector employment was 78% and private sector 22%, compared to 91.8% to 8.2% in 1981. The average monthly wage as of July 2013 is 466 Cuban pesos, which are worth about US $19. Before the collapse of the Soviet Union, Cuba depended on Moscow for substantial aid and sheltered markets for its exports. The removal of these subsidies (for example the oil) sent the Cuban economy into a rapid depression known in Cuba as the Special Period.

Cuba took limited free market-oriented measures to alleviate severe shortages of food, consumer goods, and services. These steps included allowing some self-employment in certain retail and light manufacturing sectors, the legalization of the use of the US dollar in business, and the encouragement of tourism. Cuba has developed a unique urban farm system (the organopónicos) to compensate for the end of food imports from the Soviet Union. In 2010, for the first time in decades, Cubans were allowed to build their own houses.

The name Cuba comes from the Taíno language. The exact meaning of the name is unclear but it may be translated either as where fertile land is abundant, or great place.

Havana, the capital of Cuba, is the Caribbean's largest city, covering 281 square miles with 2.1 million Habaneros calling it home. Founded by the Spanish in the 16th century, Havana is on the northern coast of Cuba. As a port city situated between the Caribbean and the Gulf of Mexico, it was a stopping ground for Spanish ships carrying treasure between the Old and the New World. The Malecon, a broad esplanade and seawall, spans the coast, bringing in cool breezes from the Straits of Florida.

With over 1,000,000 international tourists visiting Havana in 2010, tourism is a growing industry, up 20 percent from 2005. The city is rife with museums, site-seeing tours, theaters supporting performing arts, and a thriving nightlife replete with mambo and salsa dancing to hot Cuban jazz.

Due to Havana's almost five hundred year existence, the city boasts some of the most diverse styles of architecture in the world, from castles built in the late 16th century to modernist present-day high-rises. There are French neo-classic buildings from the 1800s, colonial and Baroque military-like facades from the 1600s and 1700s, and art deco buildings from the 1900s like the Karl Marx Theater. It's a melting pot of styles and centuries, as diverse as the Cubans themselves.

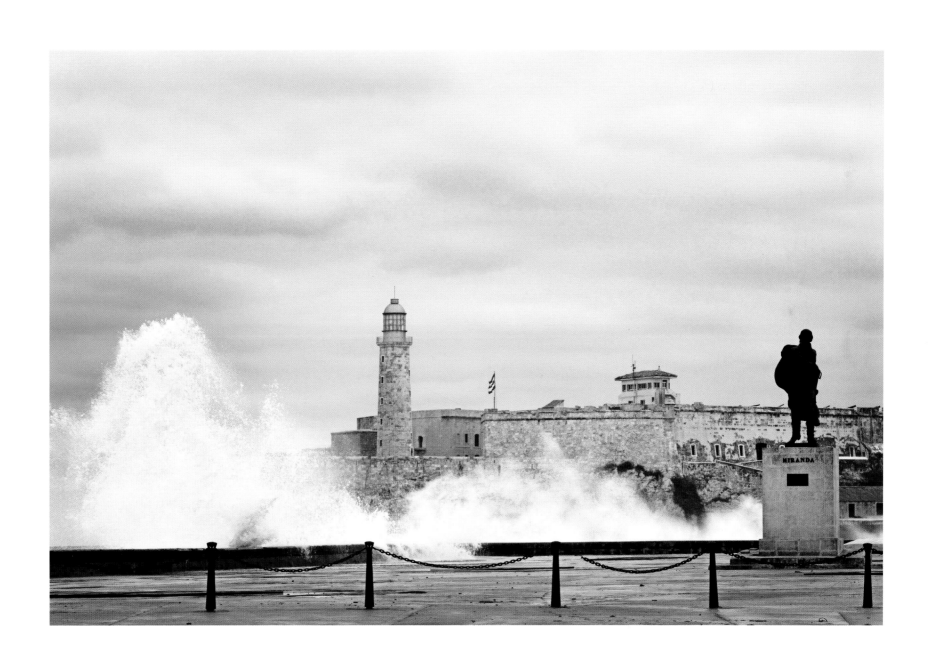

Malecon, Monumento a Francisco Miranda, Castillo de los Tres Santos Reyes de Morro, Havana

The Intellectual and Power in Cuba

—Omar Pérez

Tr. Kristin Dykstra

1. Consider my passport. The personal data line where you define your "profession" lists "writer." Though I'm not trying to mimic Mayakovsky, I can't forget the taste, the euphoria of that poem we learned in school: I'm a poet, I serve the power of the people. In real life I limit myself to verifying just one fact: the Republic of Cuba recognizes my condition as a writer. This has two secondary effects. One, that my mother is proud. The other, that police at Customs ask me, "What do you write?" "Poetry," I answer. On a certain occasion, a certain policeman took it farther than the others. The incident took place at JFK airport in New York some weeks after September 11: he asked, "What kind of poetry?"

"Philosophical poetry."

"What is philosophical poetry?" he insisted, putting me in an awkward situation. I don't remember what I answered. I don't know what poetry is, much less what philosophical poetry would be, or even philosophy, bios kubernitis, governor of life, as the ancient Greeks said. Despite the difficulty of the question I must have given a satisfactory answer in the face of power incarnate. It's not lost on me that a good many truths are told in order to get out of tight spots, then forgotten. You'll ask what relationship the interrogation by a New York airport officer has to the theme in question. First, the dialogue between poetry and power is always the same, latitude and circumstance aside. Second, the situation of a poet confronted by power in Cuba is not disconnected from his situation when confronted by power in the United States of North America. This point, which might seem to a European intellectual like a mere theoretical sleight of hand, has been a constant reality for more than a century on our lands. Don't worry—this time I'm not going to quote José Martí. I proceed with the interrogation: the uniform persisted, "Your name is Omar. Are you Arab?"

"Not that I know of."

"Then are you a Muslim?" Good question: in the sense of being "abandoned of God," be God whatever he is—Tao, Buddha, cosmos—we are all Muslim. However, not wanting these theological considerations to aggravate my status as a poet originating from a nation now considered "terrorist," I said no.

"Then why is your name Omar?"

"In honor of the great poet Omar el Khayamm—Persian, not Arab—my mother gave me his name."

Persian or Arab, Cuban, atheist or believer: poet, always suspect to power constituted in uniform. So far though, in one place or another, that power has—after some interrogation—let me go on down my road in peace.

2. Every time I come back to Cuba, I return with intensity to the fundamental political condition: daily life. I feel an imperative to organize political discourse, and poetic discourse, not around criticism of power incarnate but around observation of the way of life of the people, beginning with mine. I understand this observation to ennoble humans in their existence and prepare them to modify reality. Their reality. In this process I am not the passive object of some power external to me, telling me what I should see and how, what I should or should not change and in what way. Not as long as I'm a poet, here and there, lord of my own reality. Naïve? Romantic? Pushkin said it, that he was neither safe nor completely defenseless in the face of power: the poet should be a little stupid. But it's not this basic and immemorial stupidity of the human-poet that blinds or denigrates. In it reside ideals, the sediment of our eternal life, and these are eternally realizable.

Now what, etymologically speaking, is criticism without crisis? Let's welcome this crisis of systems, discourses, powers that in the end is the crisis of an entire civilization and its model of consciousness. Without crisis not even poetry would be given to us today; not even reflection; not even philosophy. Who will throw the first stone at it? Today, obviously, it has come to be considered a normal act to throw stones, invectives, bombs. He who criticizes today should also know how to plant seeds for flowers. And if necessary, to throw them. This would be the greatest act of power.

3. I pause a moment on this point. Maybe it will be said that I have tried to use rhetoric to evade the matter of the relationship between the intellectual and power in Cuba? Not by a long shot. I have firsthand knowledge of censorship and other extreme resources of political therapy. They can't dissuade the poet who has devoted his energies to spying on a higher state of consciousness. Having made the poet hostage to reality is not the fault or privilege of any specific system. Even when all systems, by their nature of being systems, may have in some moment been attributed the doubtful merit of subjugating all nature, and therefore human nature and the root of poetry, it has in reality been the poet, in his or her purest impulse and at the four cardinal points of the world, who has decided to subjugate him—or herself, to remain among men, chanting. The force of this choice is what has caused the poet to subsist among the persecuted and the silenced to the present day: we who will watch the sun move across the other side of the mountain tomorrow.

4. I go out for a walk. Yes, I know. It's the devastated city you've all seen on the pages of Le Monde Diplomatique and in Wim Wenders' Buena Vista Social Club. I leave my son at the door of the renovated school, formerly a store for goods decommissioned by the state. According to the state, my son's future is guaranteed. According to my instincts as a father and a poet, his present is no more or less uncertain than that of all inhabitants of this planet in turmoil, our everyday volcano. The price of the noni, or Indian mulberry, a prodigious fruit said to possess 101 curative properties, is 5 pesos per bundle in the state market and 7 pesos at the herbalist's store. The young women I bump into on the road to central Havana look as beautiful and healthy as ever, "like precious pearls, the adornment of dream . . ." On the Malecón a typical scene of latin socialism: one man in charge of the excavator, working; 19 men observing. They're not curious; they're workers and bosses on the job. These gesticulate, those remain absorbed in contemplation. One even stretches his body along the wall, rests his head on a colleague's thigh, and smokes a cigarette. Marx and Lafargue, father and son-in-law, eternally reconciled: the right to work and the right to rest in dialectical unity.

For their part, those people from think tanks of the Christian and materialist West who have determined Cuba, among other non-hegemonic nations, to be a poor country, profess not only an extreme and fundamentalist materialism but also a limited vision, one impoverished in turn in the spirit-matter of development and movement. Because spirit-matter is not just object, its liberty is not only free will, and its realization is not only gratification.

5. Who said that all reality was rational: an ideologue in the service of a party or a poet in the service of publicity? In the propaganda of capitalist society the call to an individualist carpe diem is paramount: be yourself. And even, as I have observed in the Amsterdam airport, be a tiger. Don't let others consume for you. Here and now, consume anything, so long as the one consuming it is you. Get a life. In the most austere society through which Cubans have ever lived, propaganda attempts to activate other regions of consciousness. For example: ideas cannot be defeated, ideas are immortal, etcetera. Platon dixit, Marx dixit. There is, furthermore, a word in which commercial and political propaganda coincide: revolution. And still another word into which all ideological, economic, mystic, and sumptuary messages and values flow: energy. Supreme mystery of our unreality.

As long as I'm an individual, a poet, and in a certain way an idiot—

following the Hellenic interpretation of an independent individual—I find both calls sympathetic and stimulating. Full of grace, yes, and empty of meaning. Grace and meaning: here is one of the points around which the intellectual can take action in the face of power and the social matrix. I propose combinations. Such as: Be yourself, ideas are immortal. Naturally one knows that to dialogue directly with power, one must have better tools than the mere verbal and conceptual ingenuity that underlies all philosophical poetry. But at the end of the day we won't lack for work or for materia prima: how do we go back and fill these pairings with meaning if not by using contraries, by using the badly applied concepts that we inherited from our decomposed civilization: messianism and productivity, savings and dignity, future and death, honesty and democracy, revolution and consumption. Revolution: today they name you in advertisements at the four corners of the world: alleluia!

Omar Pérez (b. Havana, Cuba, 1964) is a prizewinning poet, translator, and essayist. His poetry collections include Algo de lo sagrado (Editorial Unión, 1996), ¿Oíste hablar del gato de pelea? (Letras Cubanas, 1999), Canciones y Letanías (Extramuros, 2002), Something of the Sacred (bilingual edition of Algo de lo sagrado with translations by Kristin Dykstra, Factory School, New York, 2007), and Lingua Franca (Unión, 2009). He is also the author of a collection of essays about poetry and translation, La perseverancia de un hombre oscuro (National Critics' Prize / Letras Cubanas, 2000). Among his more recent publications are Crítica de la razón puta (Nicolás Guillén Prize / Letras Cubanas, 2010); Did you hear about the fighting cat?, a bilingual edition of ¿Oíste hablar del gato de pelea? released by British publisher Shearsman in 2010, also translated by Dykstra; and the 2011 essay collection El corazón mediterráneo. Among his many translations are works by contemporary writers in Italy, Africa, Great Britain and the United States, as well as a rendition of Shakespeare's As You Like It. Pérez has also worked in related areas such as journalism and cultural radio programming, and as a percussionist he participates in collaborative works with dancers.

Kristin Dykstra's translations and critical introductions will be featured in three bilingual editions of contemporary Cuban poetry forthcoming from the University of Alabama Press: Other Letters to Milena, by Reina María Rodríguez; Breach of Trust, by Ángel Escobar; and The Counterpunch (And Other Horizontal Poems), by Juan Carlos Flores. She received a 2012 NEA Fellowship for Literary Translation to complete the collection Catch and Release, by Rodríguez (Cuba). Dykstra previously translated several books of poetry from Cuba, including works by Omar Pérez and Rodríguez. She co-edits Mandorla: New Writing from the Americas with Roberto Tejada and Gabriel Bernal Granados and is Professor of English at Illinois State University.

Cuba y su cultura

—Orlando Mendez Montero

A la cultura cubana muchos coinciden en compararla con candente crisol de mezcla heterogénea, donde se vertieron en abundancia los componentes étnicos y culturales de pueblos ibéricos—andaluces, castellanos, valencianos y navarros, gallegos y catalanes—y muchos canarios, todos de España; y de pueblos africanos—congos, carabalíes, mandingas, lucumíes y yorubas. Y en el transcurrir del tiempo, del siglo XVI a más acá, también es justo recordar los aportes en chinos y japoneses, franceses y latinoamericanos, norteamericanos, árabes y hebreos, aunque todos fueran en menor cuantía.

Lo cierto es que tal conjunto fue dando lugar a un pueblo nuevo, a una nueva nación que, a partir del XIX, a luchado denodada y continuamente por su autoafirmación y su reconocimiento, con un concepto de Patria que le cuelga sobre el pecho cual talismán.

Isla larga, mejor, archipiélago, pues al país lo componen más de 1600 cayos e islas, de éstas, las mayores son la llamada también Cuba y la Isla de la Juventud y Cayo Romano. Todos dispuestos a su largo en el trópico caribeño, rodeados de hermosas playas de arena fina y mar complaciente, y adornados con palmeras, con alturas más bien mesuradas, dulces valles, ríos de poco caudal, enigmáticas cavernas y mogotes singulares. Pareciera que el paraíso terrenal se hubiera venido de vacaciones al Caribe.

Su cultura se ha hecho más conocida para sus vecinos del mundo mediante manifestaciones como su música—changüí, son, danzón, guaracha, rumba, mambo, bolero, cha-cha-chá—y el dispuesto temperamento de su gente, tanto para fiestear y compartir afectos como para asumir las más difíciles tareas.

En el último medio siglo, Revolución mediante, estas y otras manifestaciones han alcanzado niveles de desarrollo no antes vistos aquí, resultados de un empeño de quehaceres múltiples que incluyeron la Campaña de Alfabetización, una especie de entusiasta cruzada juvenil—jóvenes estudiantes convertidos de pronto en maestros—que se desplegó por todos los rincones del país para, en un año, enseñar a leer y escribir a aquel 30 % de nuestra población adulta—alrededor de un millón de personas—y abrir así un permanente proceso de aprendizaje y superación personal que ha implicado prácticamente a toda la población.

Esto fue en 1961, además de la derrotada invasión mercenaria de Playa Girón, también conocida como de Bahía de Cochinos. Y así mismo fue en ese año—cuando todavía prácticamente humeaban los cañones milicianos que defendieron la integridad de la Patria—aquella reunión de varios días de Fidel y otros dirigentes revolucionarios con una masiva representación de artistas y escritores, para dejar proclamada la plena libertad creativa como principio básico inherente a aquel empeño gubernamental por el desarrollo popular de la nación inaugurado el mismo primer día de enero de 1959.

Comenzó desde aquel entonces el desarrollo de una industria para la creación artística cinematográfica nacional y de apoyo a la de origen latinoamericano. Las escasas bibliotecas anteriores multiplicaron ampliamente su presencia en todos los municipios del país, junto a los museos y las galerías de arte municipales, objetos de nueva iniciativa. Se creó una Escuela Nacional de Arte en la capital, para la enseñanza masiva del ballet, la danza, la música, el arte dramático y las artes plásticas, y luego se multiplicaron las escuelas de arte por todo el país y más tarde, se creó el Instituto Superior de Arte: la Universidad de las Artes de Cuba.

Así, se fue enriqueciendo con nuevas jóvenes figuras el Ballet Alicia Alonso, convertido en el Ballet Nacional de Cuba, para fundar una escuela ballerista de estilo cubano, reconocida en todo el mundo. Nacieron diversos grupos de danza folclórica, danza contemporánea, danzas regionales españolas y danzas típicas cubanas. Crecieron en número y en calidad interpretativa los grupos de música popular cubana y de otros géneros, como el jazz y la música mexicana; así también las bandas y las orquestas sinfónicas; del mismo modo que ha ocurrido con los intérpretes solistas, vocalistas e instrumentistas. Otro tanto ha venido ocurriendo con los grupos teatrales y sus integrantes; así como con los creadores de las artes plásticas: pintores, dibujantes, grabadores, escultores, fotógrafos, diseñadores, artistas del performance y del arte conceptual y el digital.

Se han ido creando eventos, concursos, exposiciones, festivales y premios para todas las especialidades y categorías, con el fin de estimular y reconocer la labor artística de nuestros creadores y su altísimo nivel técnico; los cuales han sido también reconocidos mediante el otorgamiento de diversos premios internacionales, así como con una creciente demanda de su presencia en diversos lugares del mundo; de modo que cada año muchos de estos colectivos artísticos, solistas, artistas de la plástica y cineastas recorren distintos países de todos los continentes, mostrando su calidad y estilo propio.

Paralelamente, se ha ido creando e incrementando un movimiento de artistas aficionados con base en las Casas de la Cultura levantadas en cada municipio, destinados ambos esencialmente a desarrollar el talento expresivo natural de los ciudadanos de todas las edades y sobre todo, despertar y elevar su capacidad de apreciación y disfrute de todas las manifestaciones artísticas, como vía que

Orlando Montero Méndez. Es Licenciado en Historia del Arte. Laboró durante dos décadas en los departamentos de Investigaciones y de Servicios Educacionales del Museo Nacional de Bellas Artes, de Cuba. Durante los últimos seis años se ha desempeñado como profesor en la carrera de Comunicación Social de la Universidad de La Habana, en la Escuela de Instructores de Arte y en la enseñanza preuniversitaria. Ha escrito textos divulgativos acerca de la obra de artistas de las artes plásticas cubanas para el sitio digital www.artcuba.com y la revista tabloide Arte Cubano.

contribuya al desarrollo pleno del individuo y su felicidad, a modo de complemento de la satisfacción de sus necesidades materiales. Con estos mismos fines y el de la obtención de una información veraz, inmediata y segura, se han incrementado las estaciones de transmisión y de repetición de la señal de la radio y la televisión hasta eliminar las zonas de silencio en todo el territorio nacional. Ofrecer a través de estos medios una programación que contribuya al disfrute sano y eleve su desarrollo intelectual. Del mismo modo se opera la distribución de los órganos de prensa plana. Se estimula y apoya la realización de fiestas populares y celebraciones tradicionales. Se garantiza la impresión, publicación y distribución nacional de nutridas tiradas de libros de todas las especialidades y manifestaciones literarias.

Los artistas, literatos, intelectuales e investigadores de todos los saberes cuentan para la realización de sus actividades con organismos y centros culturales y científicos, fundaciones, asociaciones; así como con congresos y otros eventos de confrontación, análisis, actualización y divulgación de experiencias y saberes.

Cuba cuenta en la actualidad con siete sitios declarados Patrimonio de la Humanidad, los cuales son los siguientes:

1982- La Habana Vieja y su sistema de fortificaciones coloniales.
1988- Trinidad y el Valle de los Ingenios, Sancti Spíritus.
1997- Castillo de San Pedro de la Roca del Morro, Santiago de Cuba.
1999- El Valle de Viñales, Pinar del Río.
1999- Parque Nacional Desembarco del Granma.
2000- Paisaje Arqueológico de las primeras plantaciones cafetaleras en elsureste de Cuba, Santiago de Cuba y Guantánamo.
2001- Parque Nacional Alejandro de Humboldt, Holguín y Guantánamo.

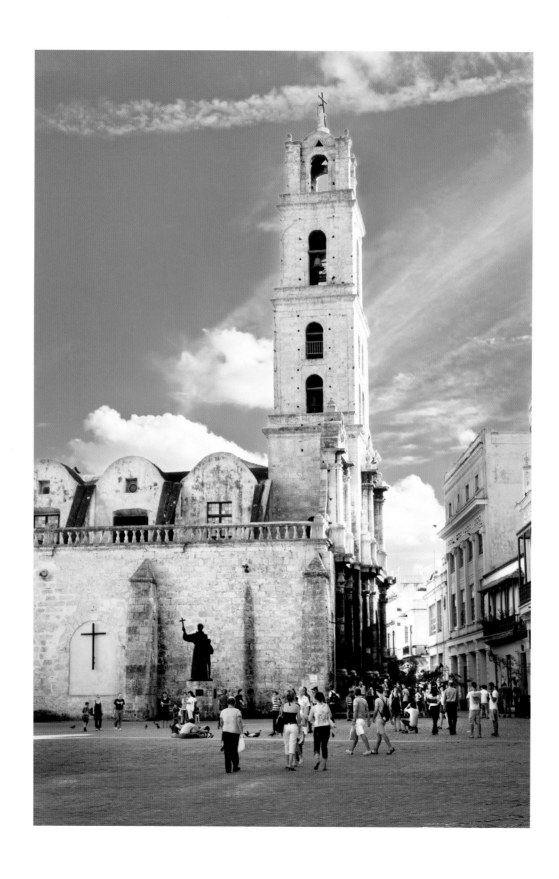

Basilica de San Francisco de Asis, Havana

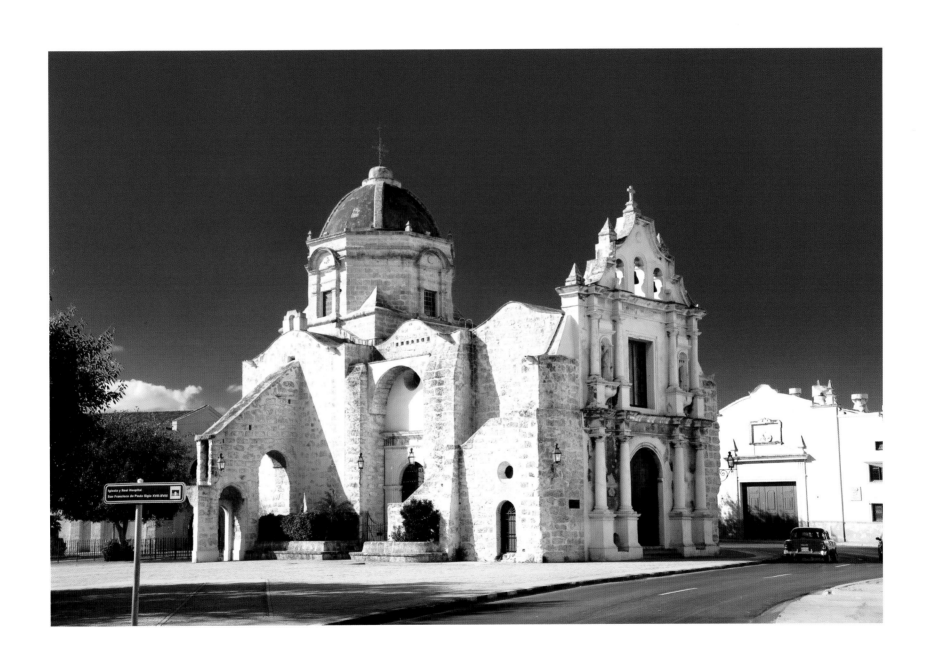

La Iglesia de San Francisco de Paula, Vieja Habana 17

18 Elevated Train Trestle, Havana

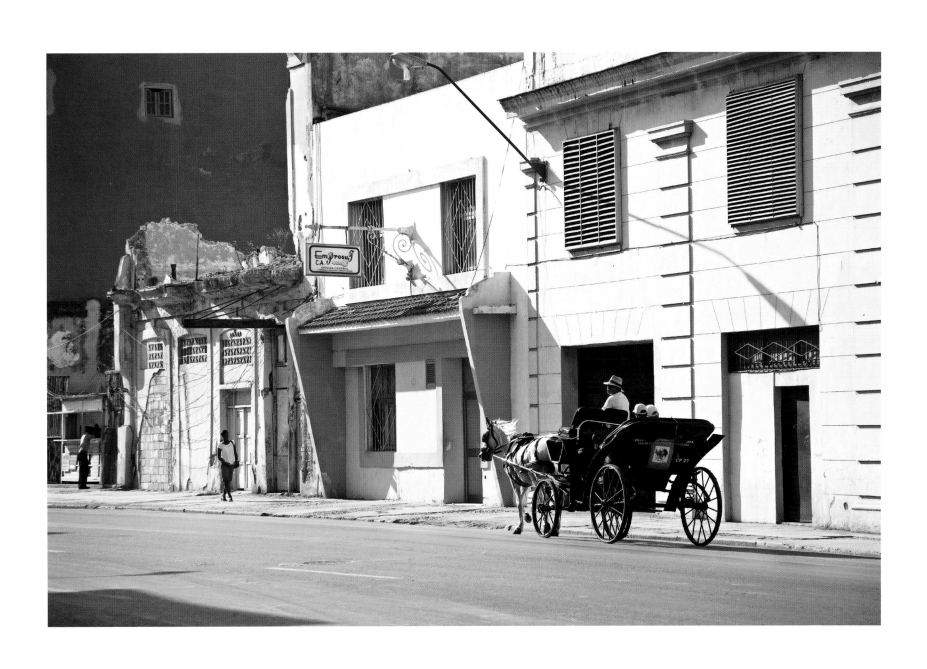

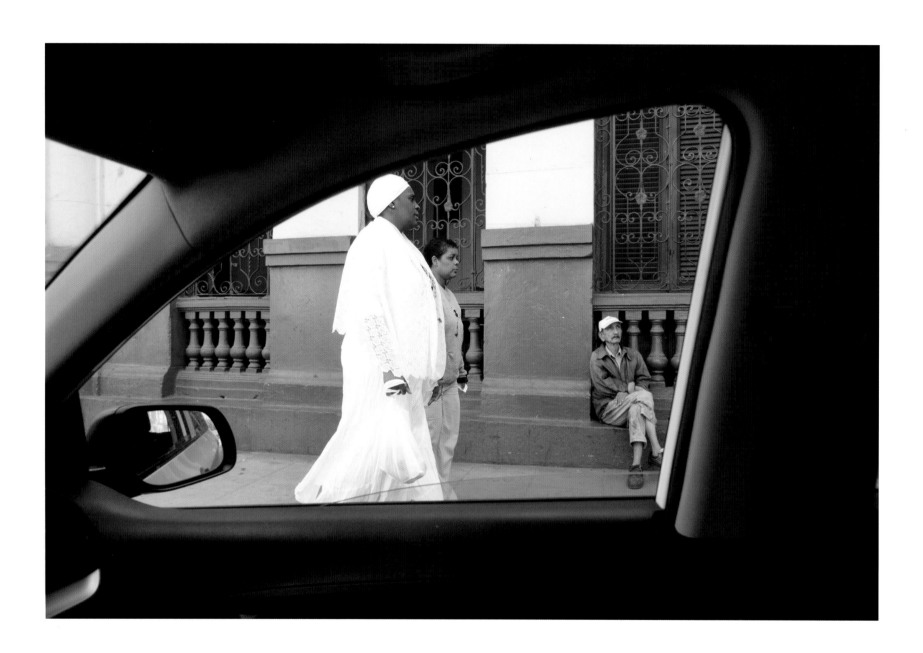

20 Santeria Worshiper, Havana

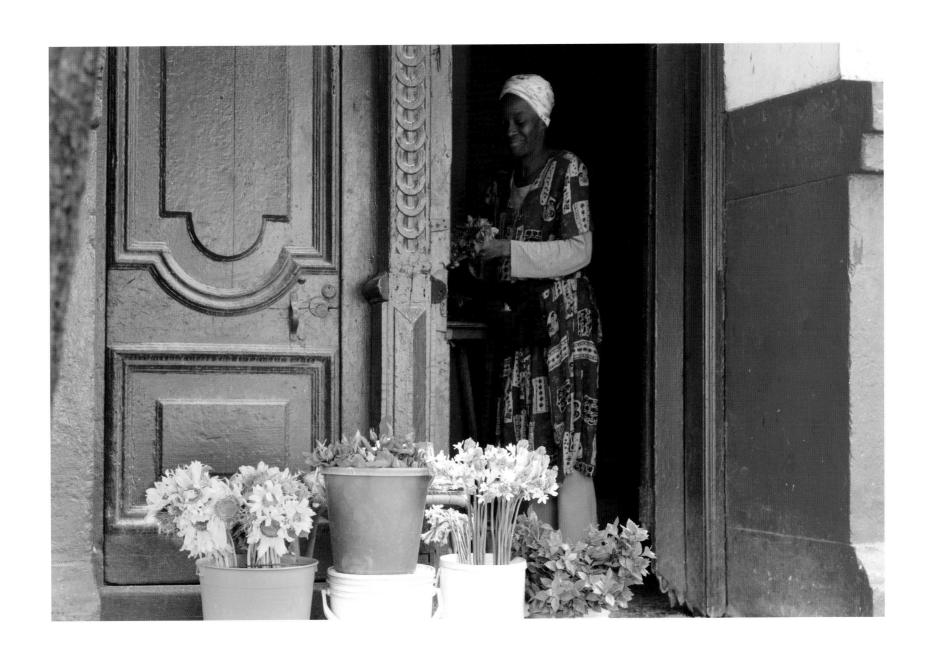

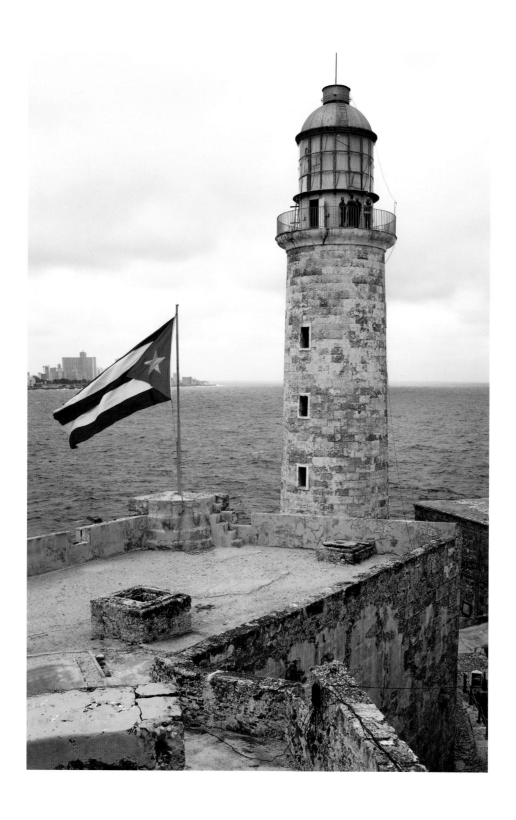

22 Faro Castillo del Morro, Havana

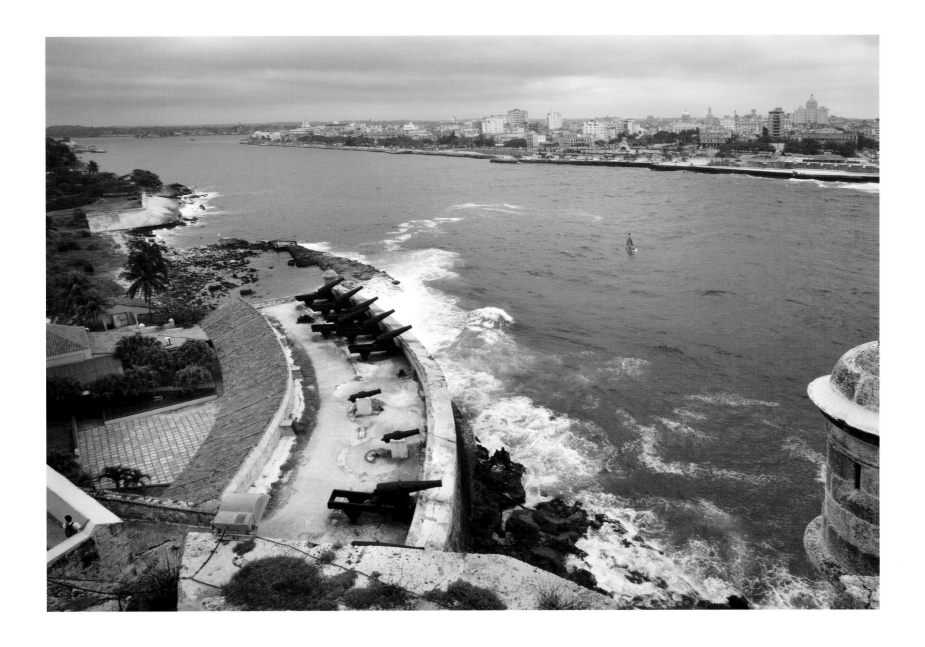

Morro Castle Spanish: Castillo de los Tres Reyes Magos del Morro is a picturesque fortress guarding the entrance to Havana bay in Havana, Cuba. Juan Bautista Antonelli, an Italian engineer, was commissioned to design the structure. When it was built in 1589, Cuba was under the control of Spain. The castle, named after the biblical Magi, was later captured by the British in 1762. Built between 1589 and 1630 and served as an important line of defense against pirate attacks and naval invasions.

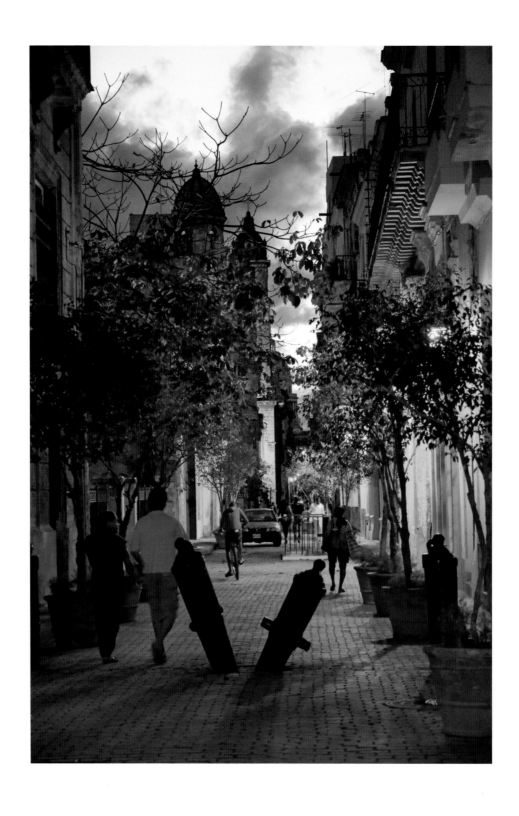

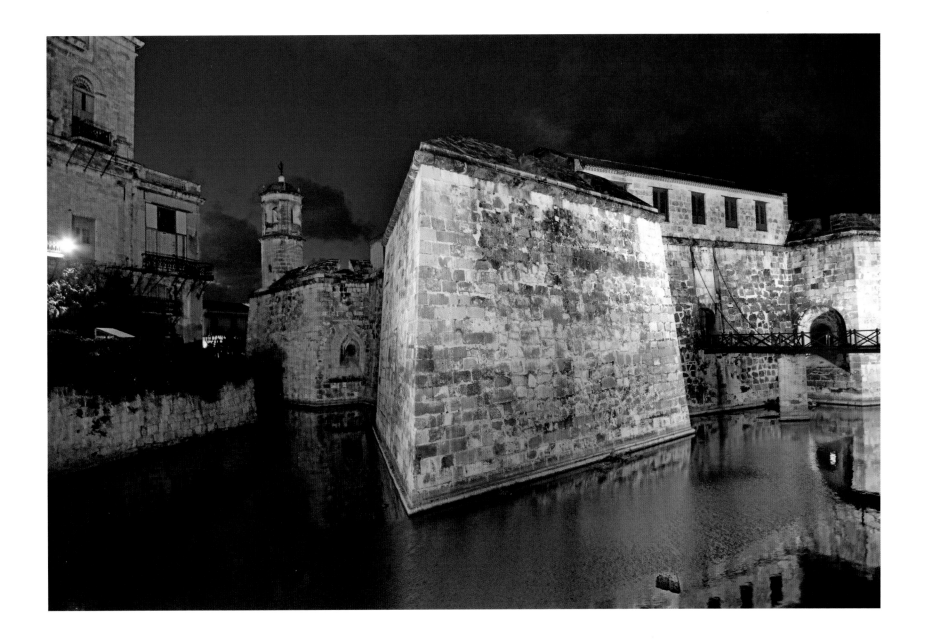

The Castillo de la Real Fuerza (Castle of the Royal Force) is a star fort on the western side of the harbour in Havana, Cuba, set back from the entrance, and bordering the Plaza de Armas. Originally built to defend against attack by pirates, it suffered from a poor strategic position, being too far inside the bay. The fort is considered to be the oldest stone fort in the Americas, and was listed in 1982 as part of the UNESCO World Heritage site of "Old Havana and its Fortifications".

THE HOTEL NACIONAL DE CUBA

A historic luxury hotel located on the Malecón in the middle of Vedado, Havana, Cuba. It stands on Taganana hill a few meters from the sea, and offers a view of Havana Harbour, the seawall and the city.

The New York architectural firm of McKim, Mead and White designed the hotel, which features a mix of styles. It opened in 1930, when Cuba was a prime travel destination for Americans, long before the United States embargo against Cuba. In its 80+ years of existence, the hotel has had many important guests.

The hotel was built on the site of the Santa Clara Battery, which dates back to 1797. Part of the battery has been preserved in the hotel's gardens, including two large coastal guns dating from the late 19th Century. There is also a small museum there featuring the 1962 Cuban missile crisis. During the crisis, Fidel Castro and Che Guevara set up their headquarters there to prepare the defense of Havana from aerial attack.

The Hotel Nacional de Cuba is a World Heritage Site and a National Monument, and it was inscribed in the World Memory Register.

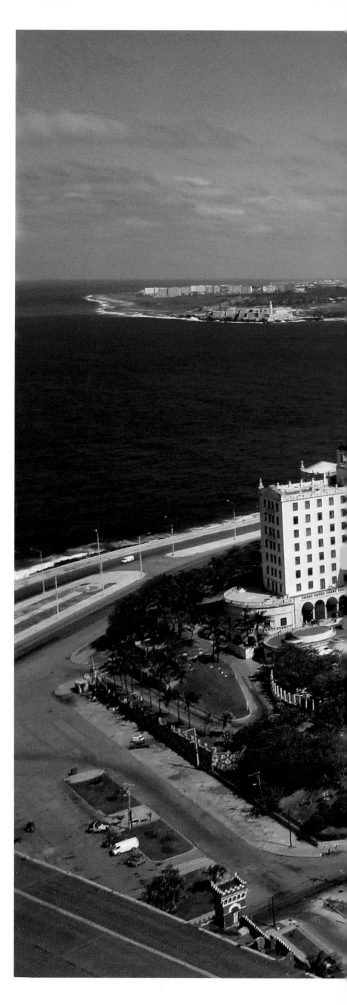

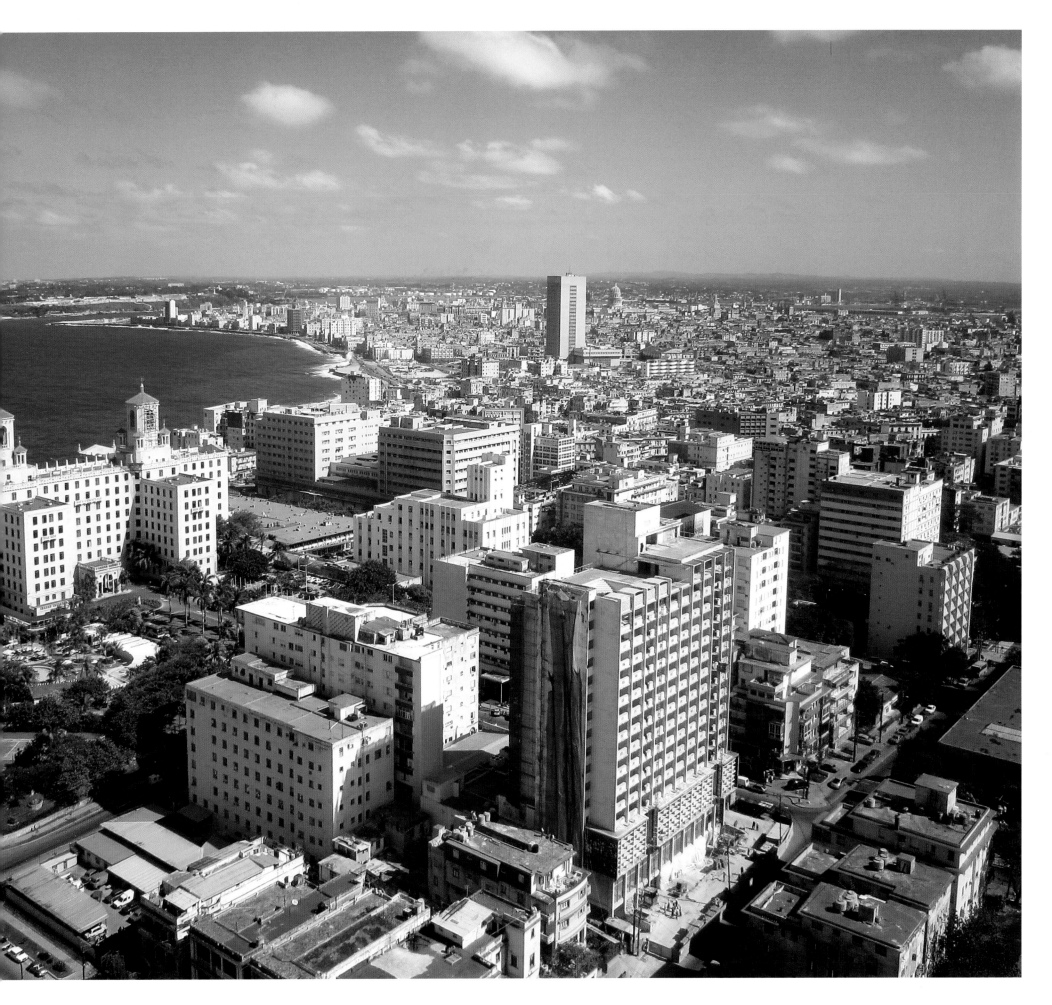

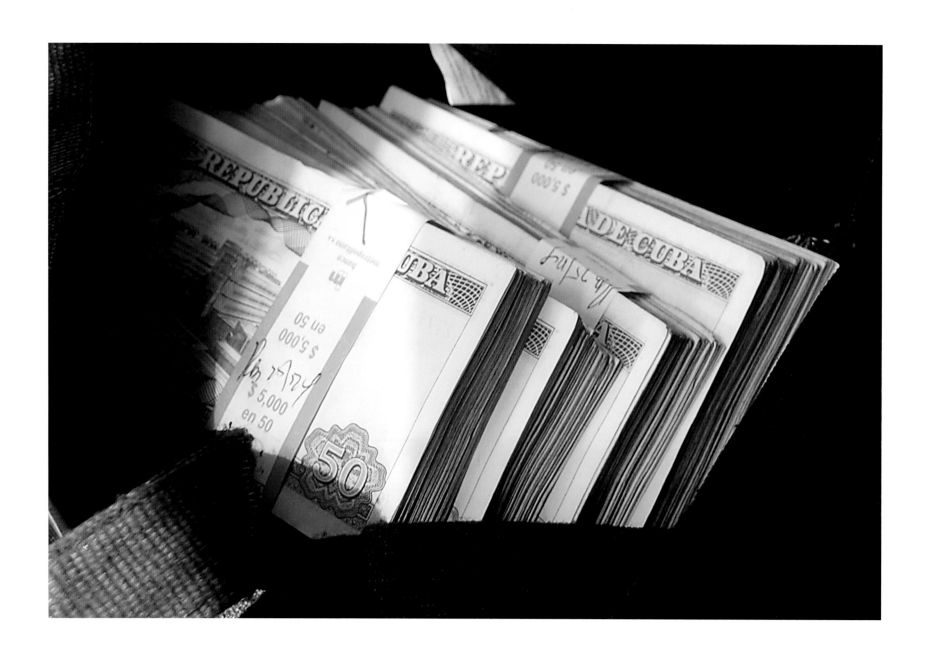

The peso, sometimes called the "national peso" or in Spanish "moneda nacional".

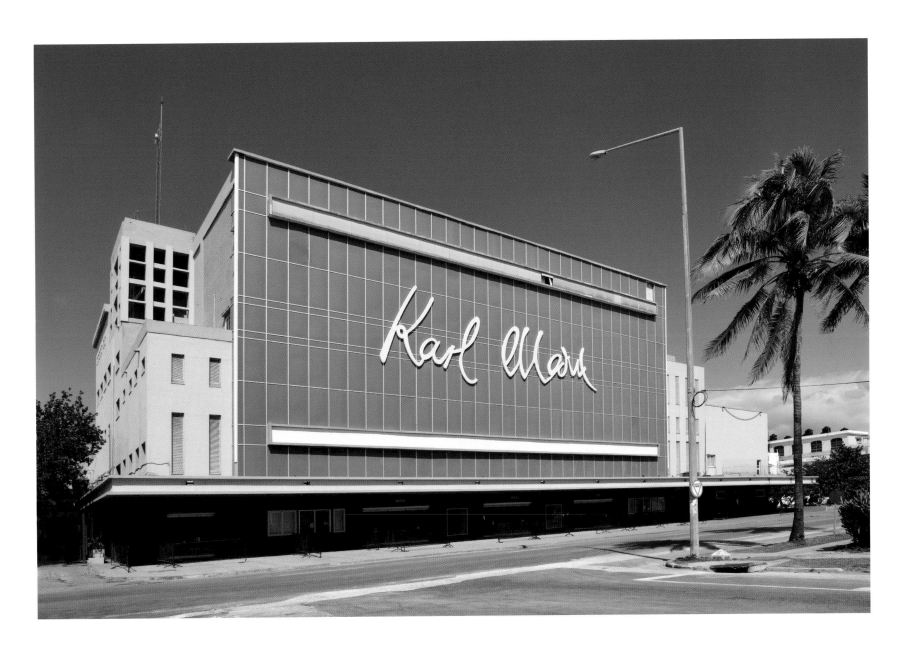

Teatro Karl Marx is a theater in Havana, Cuba, formerly known as the Teatro Blanquita, and renamed after the Cuban Revolution of 1959.
The venue has an enormous auditorium, with seating capacity of 5500 people, and is generally used for big shows by stars from Cuba and abroad.
Singer-songwriters such as Carlos Varela, Silvio Rodríguez and Pablo Milanés are among the notable performers who have graced this particular
stage. In 2001, the theater was the scene of a concert by the Welsh rock band Manic Street Preachers, which was attended by President Fidel
Castro himself. On being warned by the band that they would be playing very loud, Castro responded, "You cannot be louder than war!".

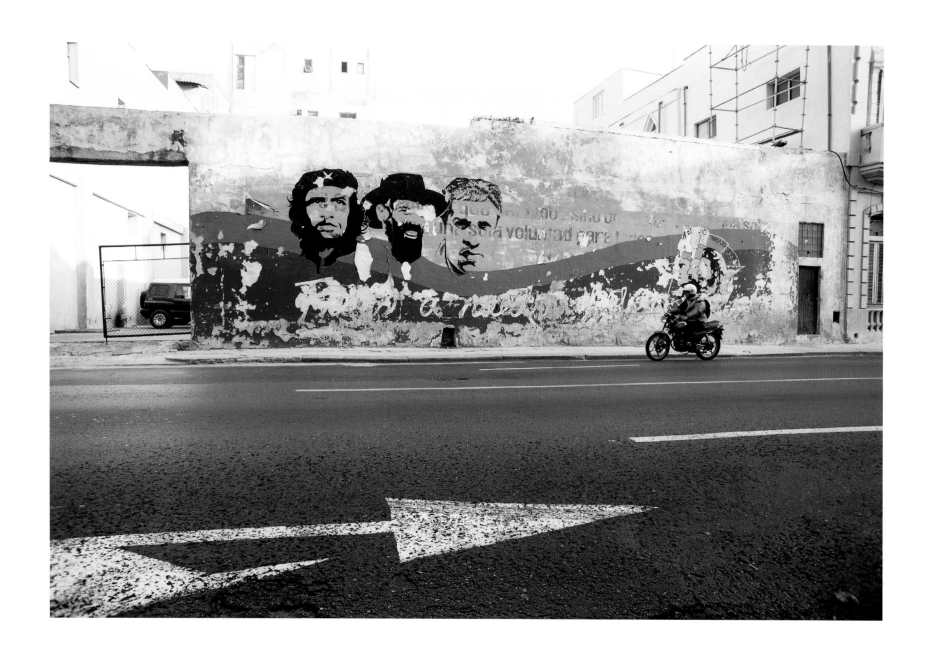

Camilo Cienfuegos Gorriarán was a Cuban revolutionary born in Lawton, Havana. Raised in an anarchist family that had left Spain before the Spanish Civil War, he became a key figure of the Cuban Revolution, along with Fidel Castro, Che Guevara, Juan Almeida Bosque, and Raúl Castro.

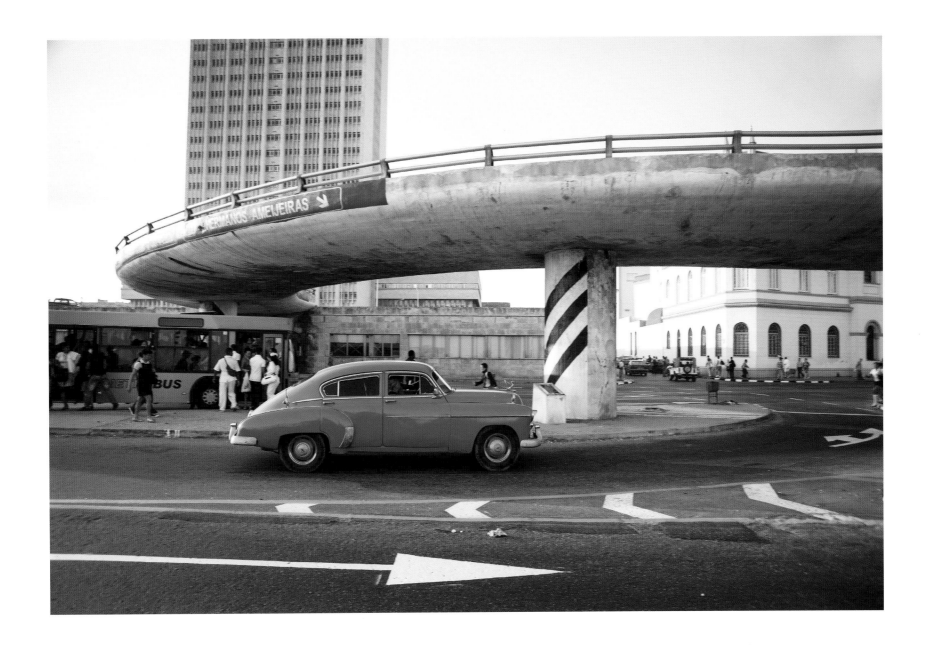

The Omnibus Metropolitanos, known as the Metrobus feeder line, connects the adjacent towns and cities in the metropolitan area with the city center. This division has one of the most used and largest urban bus fleets in the country, its fleet is made up of mostly new Chinese Yutong buses, but as well older Busscar buses.

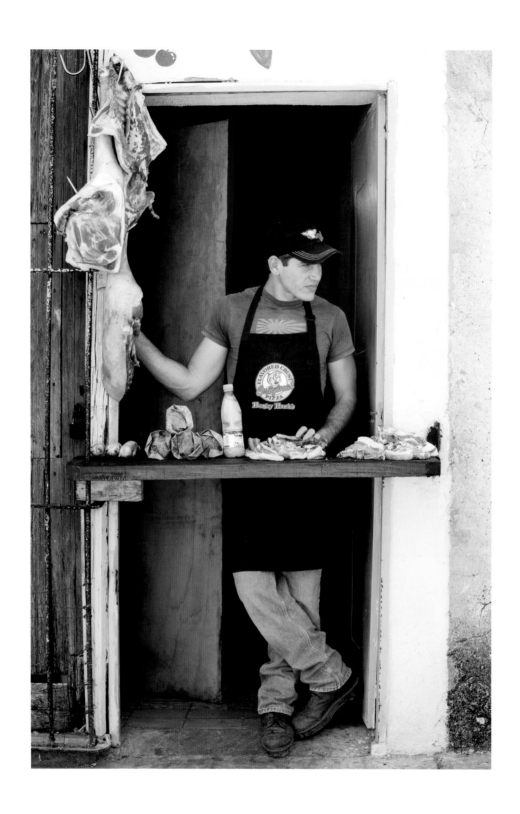

Meat is distributed at the local carnicería (meat store).

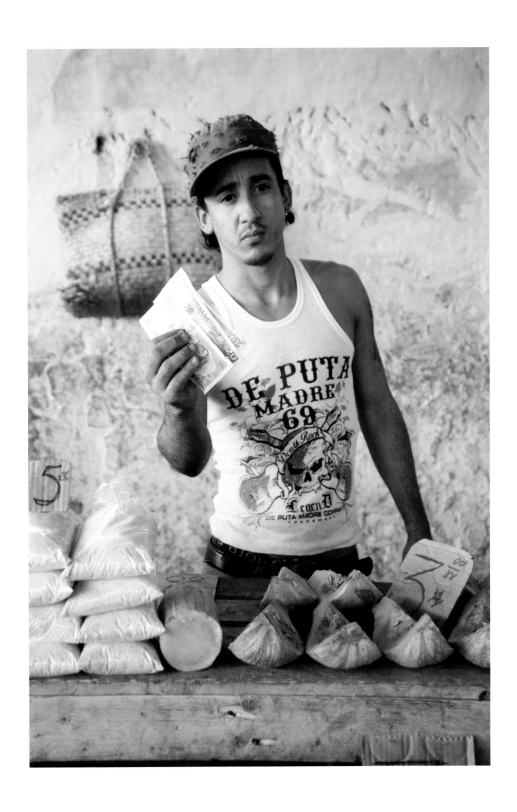

At any time of year, you'll always find locally-grown tropical fruits on offer.

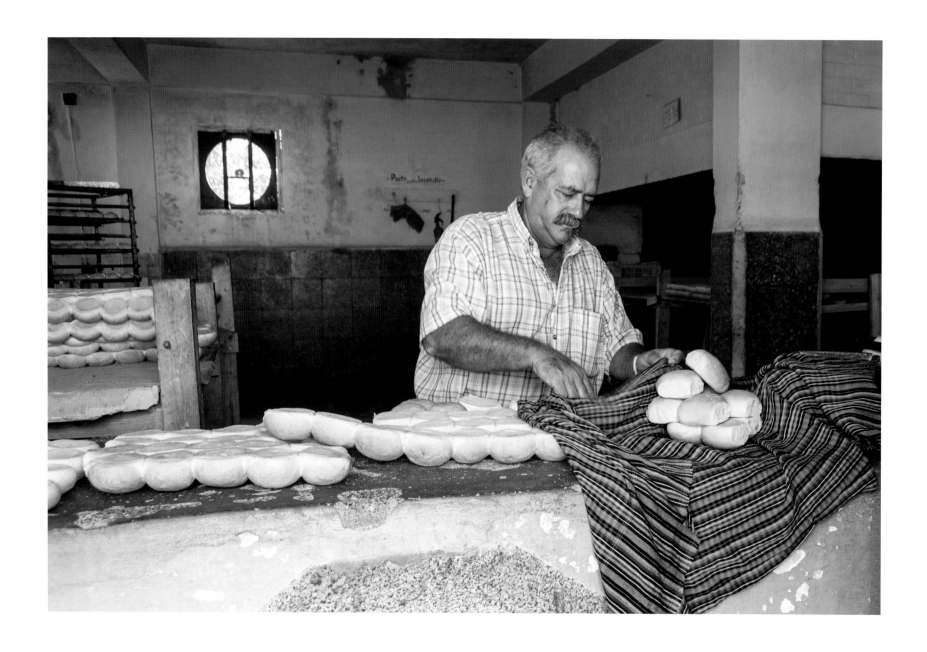

Cuban bread is a fairly simple white bread, similar to French bread and Italian bread, but has a slightly different baking method and ingredient list. It generally includes a small amount of fat in the form of lard or vegetable shortening.

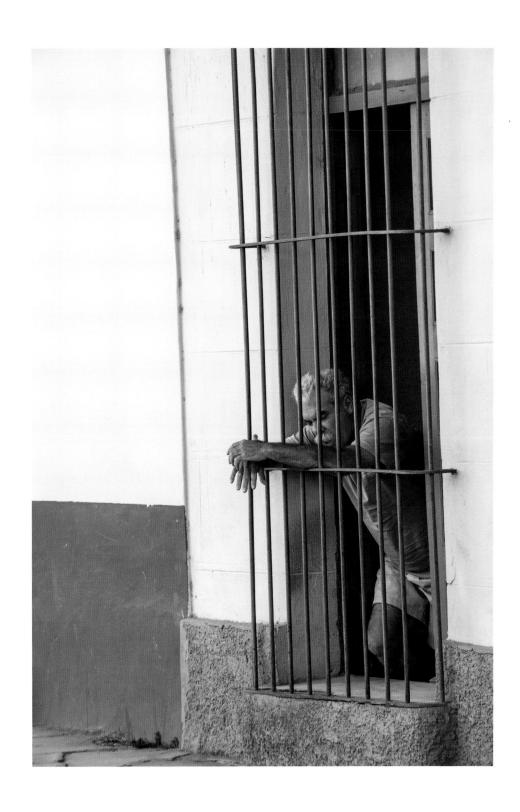

Cubans can not own the homes they live in. Citizens may swap apartments
if they find another willing person - in a practice known as permuta.

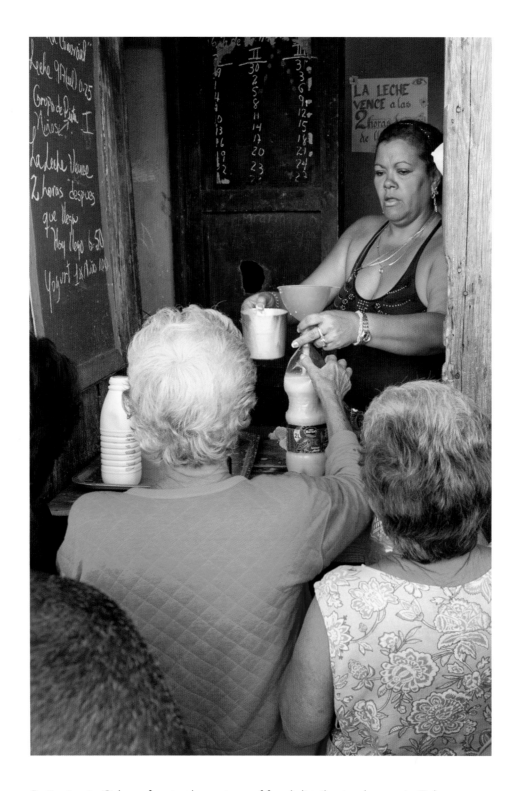

Rationing in Cuba refers to the system of food distribution known in Cuba as the Libreta de Abastecimiento "Supplies booklet". The system establishes the rations each person is allowed.

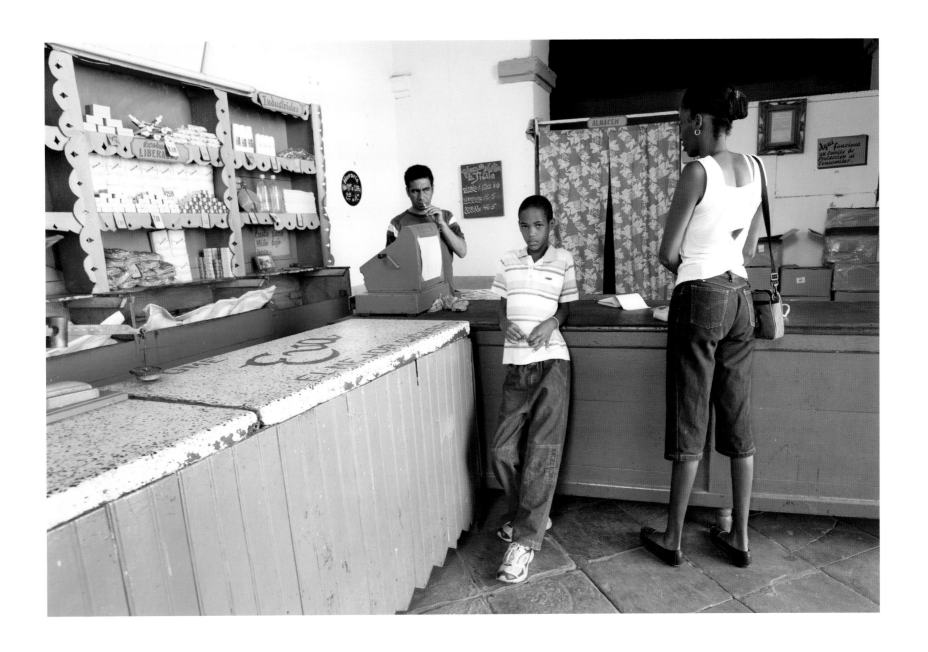

Food products are distributed at the local bodega, a store specialized in distributing rations.

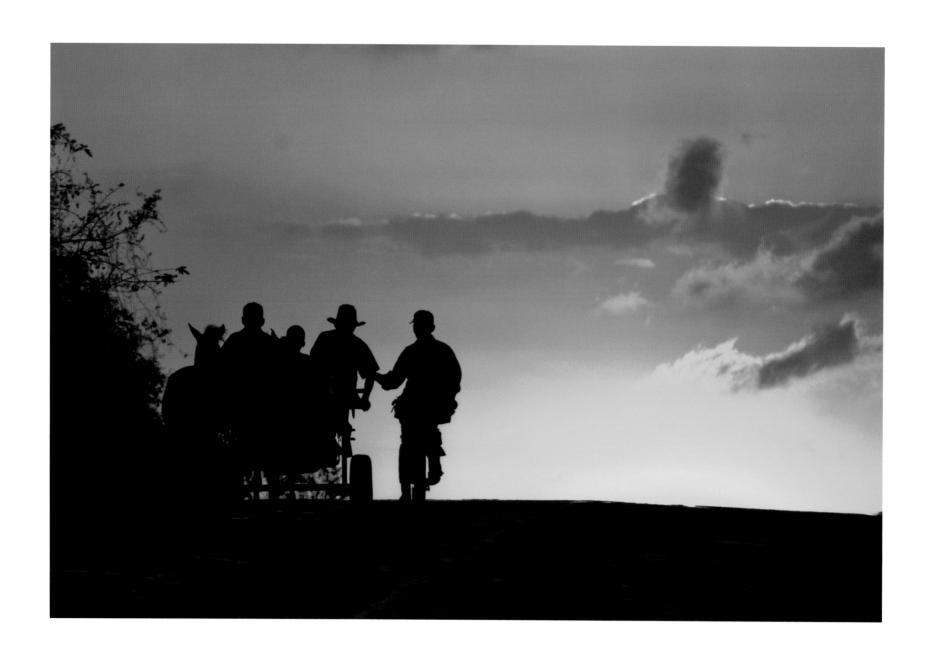

Vinales is a small town and municipality in the north-central Pinar del Río Province of Cuba.

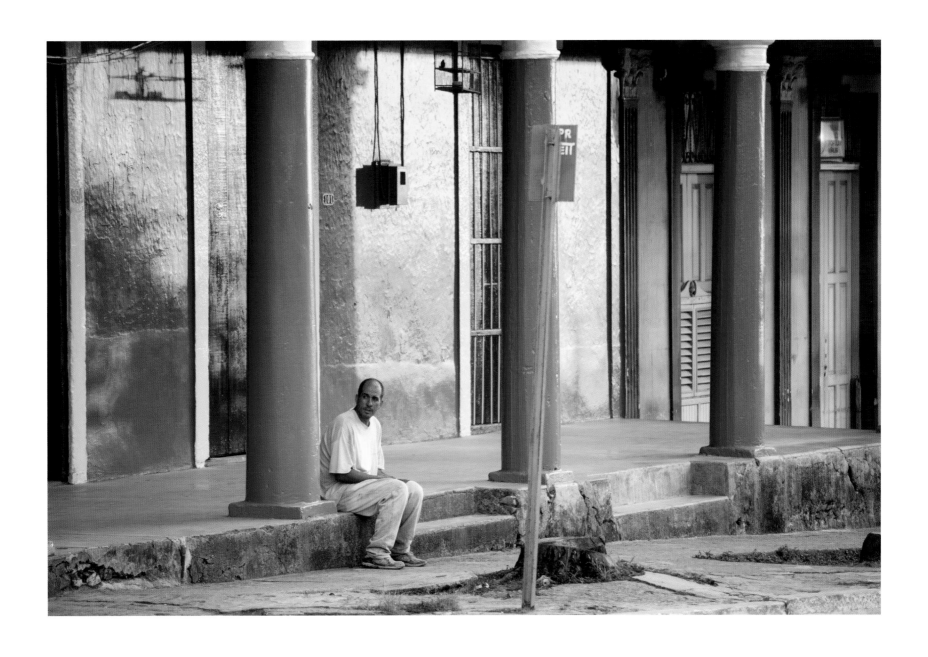

The town consists mostly of one-story houses with porches.

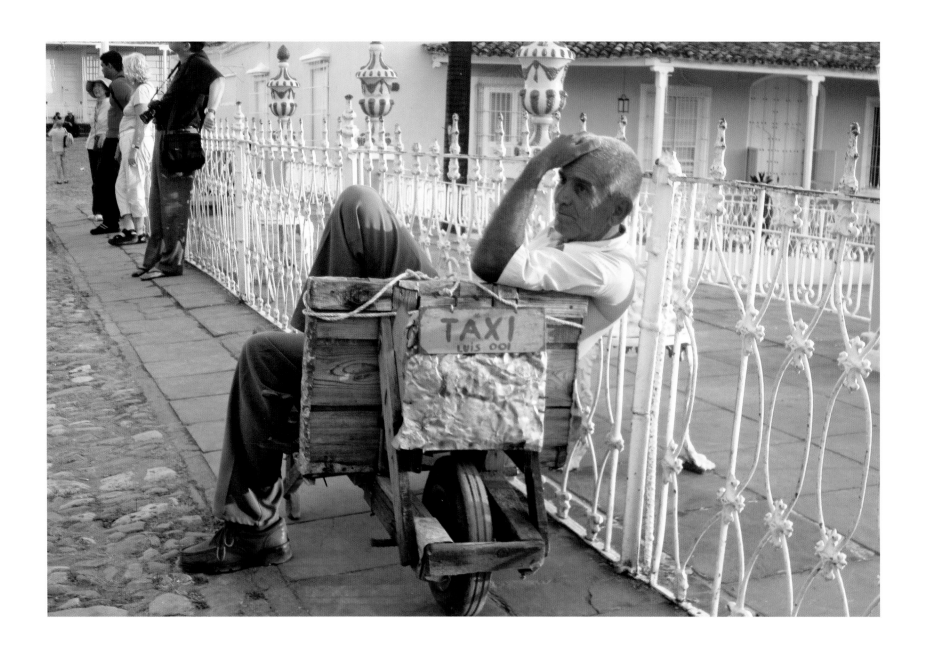

The Plaza Mayor of Trinidad is a plaza and an open air museum of Spanish colonial architecture. Only a few square blocks in size, the historic plaza area has cobblestone streets, pastel coloured houses with wrought-iron grills.

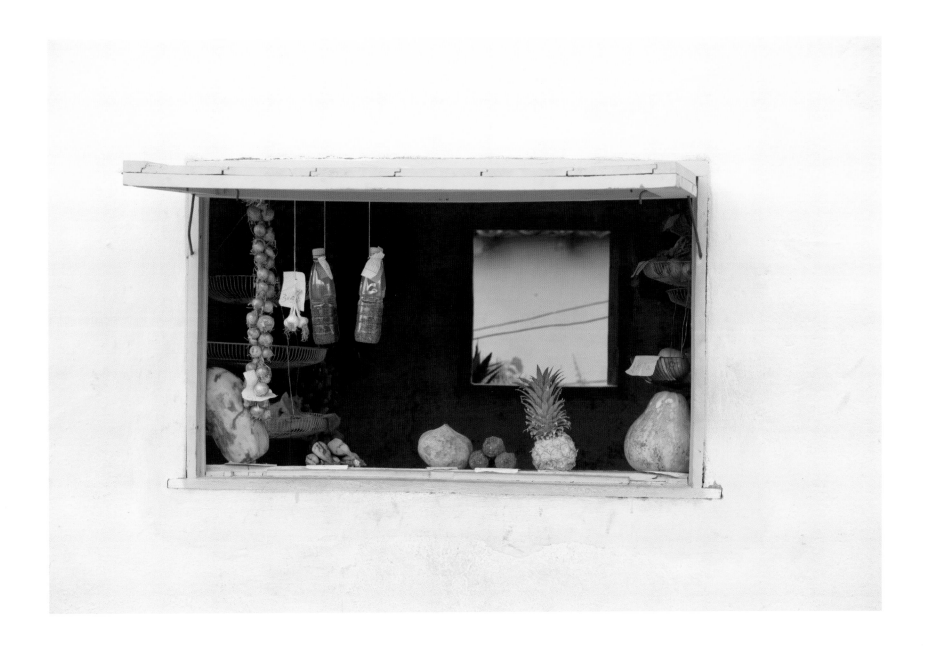

Tropical fruits
Plantains and bananas are only produced for domestic consumption. Other tropical fruits produced in Cuba are mango, papaya, pineapple, avocado, guava, coconut, and anonaceae (sugar apple family).

TRINIDAD

Trinidad is a town in the province of Sancti Spíritus, central Cuba. Together with the nearby Valle de los Ingenios, it has been one of UNESCOs World Heritage sites since 1988.

Trinidad was founded on December 23, 1514 by Diego Velázquez de Cuéllar under the name Villa de la Santísima Trinidad. Francisco Iznaga, a rich Basque landowner in the southern portion of Cuba during the first 30 years of the colonization of Cuba, was elected Mayor of Bayamo in 1540. Iznaga was the originator of a powerful lineage that finally settled in Trinidad where the Torre Iznaga is. His descendants fought for the Independence of Cuba and the Annexation to the US from 1820 to 1900. It is one of the best preserved cities in the Caribbean from the time when the sugar trade was the main industry in the region.

20 kilometers from the city is Topes de Collantes, one of Cuba's premier ecotourism centres. Another attraction is the Casilda Bay, which attracts both snorkelers and divers. A nearby islet has pristine beaches. Ancon Beach—Playa Ancon is a white sand beach and was one of the first new resorts to be developed in Cuba following the 1959 revolution.

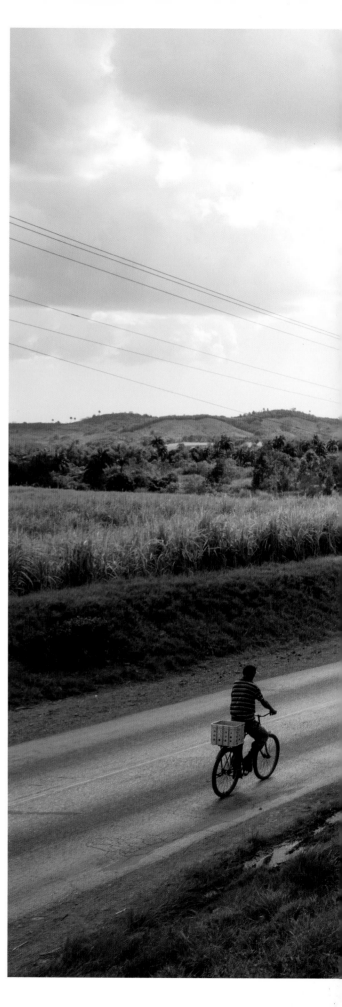

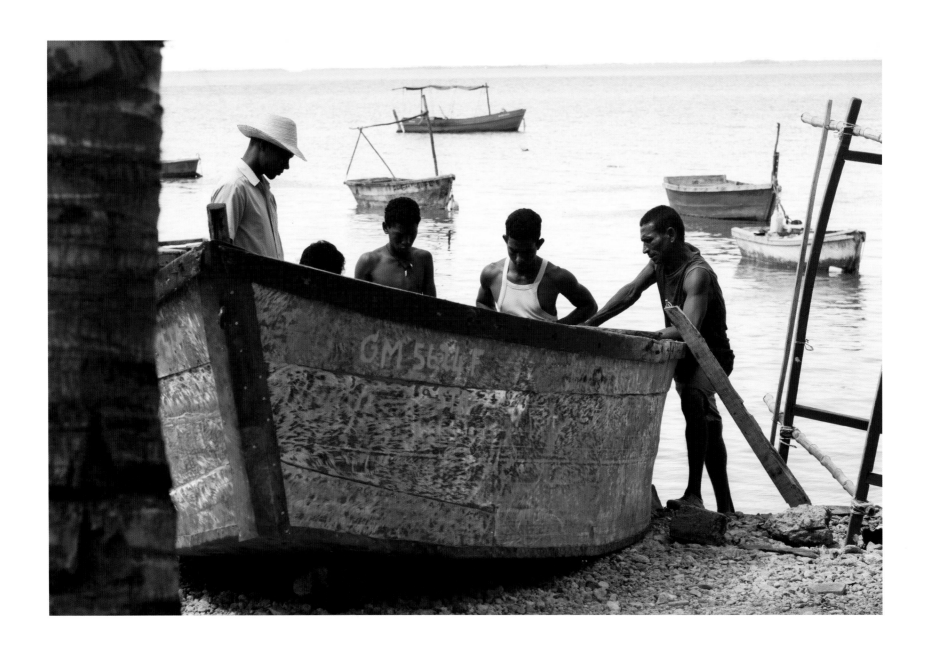

Manzanillo, founded in 1784, is a municipality and city in the Granma Province. It is a port city in the Granma Province in eastern Cuba on the Gulf of Guacanayabo, near the delta of the Cauto River. Its access is limited by the coral reefs of Cayo Perla. It was the site of four battles during the Spanish American War.

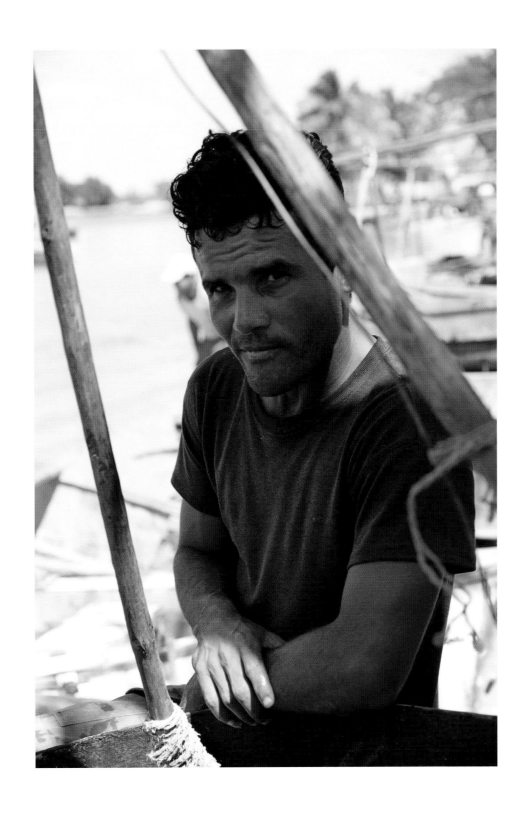

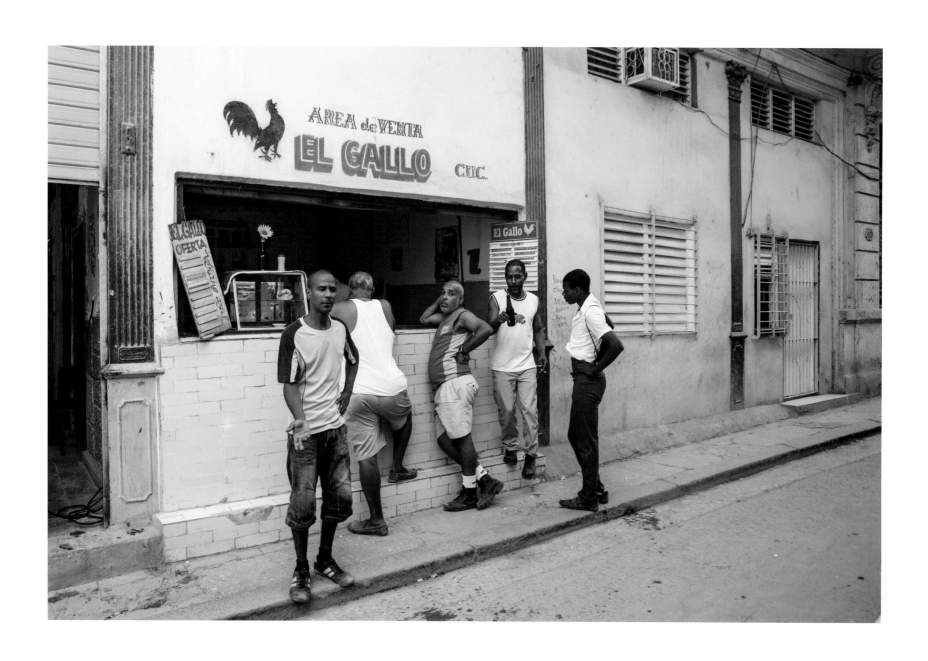

46 Chicken Restaurant, Centro Havana

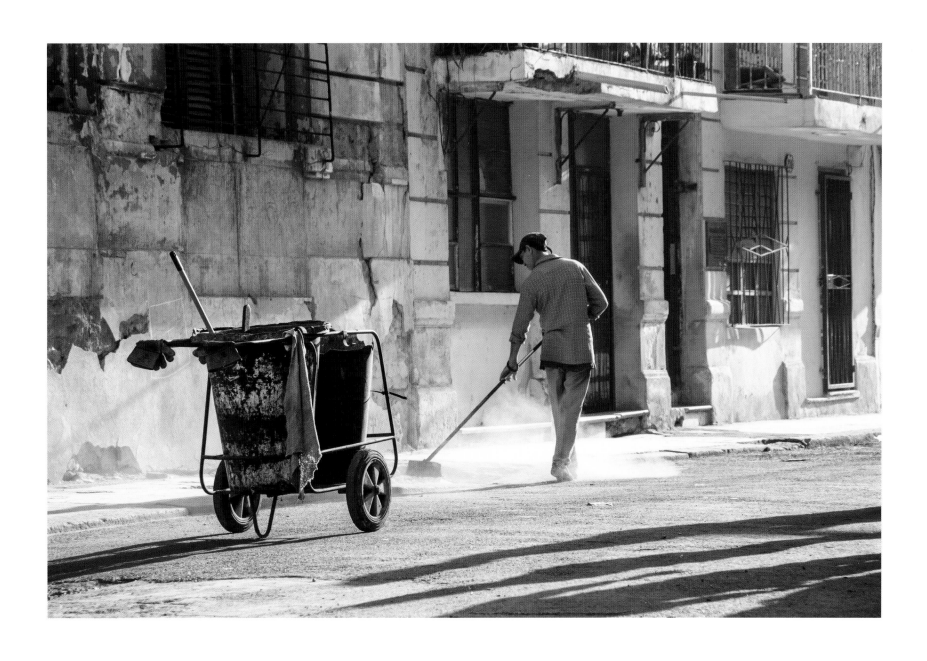

Street-sweeper, Old Havana 47

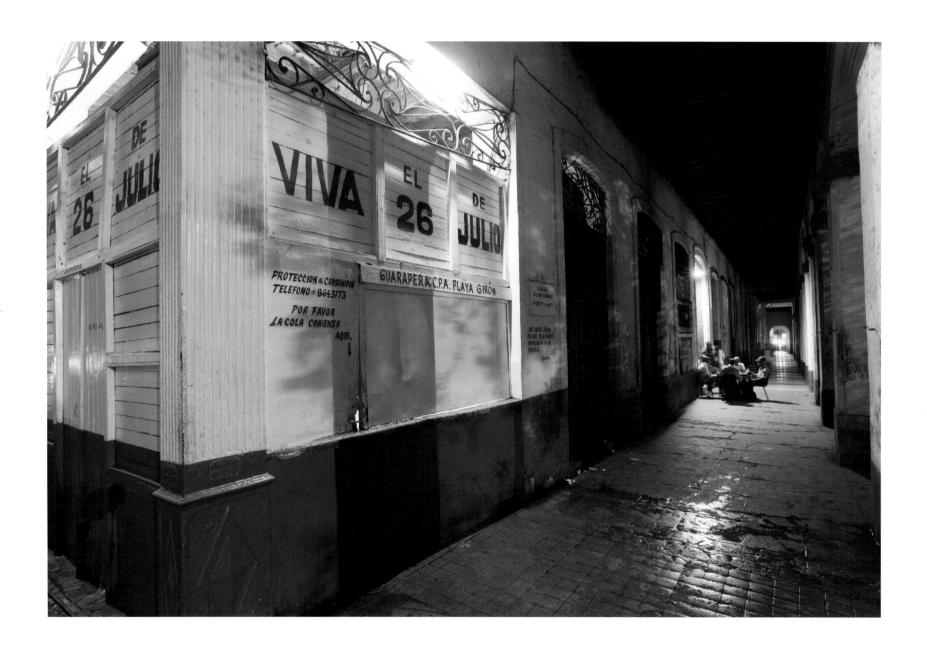

The 26th of July Movement's name originated from the failed attack on the Moncada Barracks, an army facility in the city of Santiago de Cuba. Their task was to form a disciplined guerrilla force to overthrow Batista. The movement was reorganized in Mexico in 1955 by a group of 82 exiled revolutionaries (including Fidel Castro, Raúl Castro, Camilo Cienfuegos, Arsenio Garcia Davila, Huber Matos, Juan Almeida Bosque and the Argentinian Ernesto "Che" Guevara).

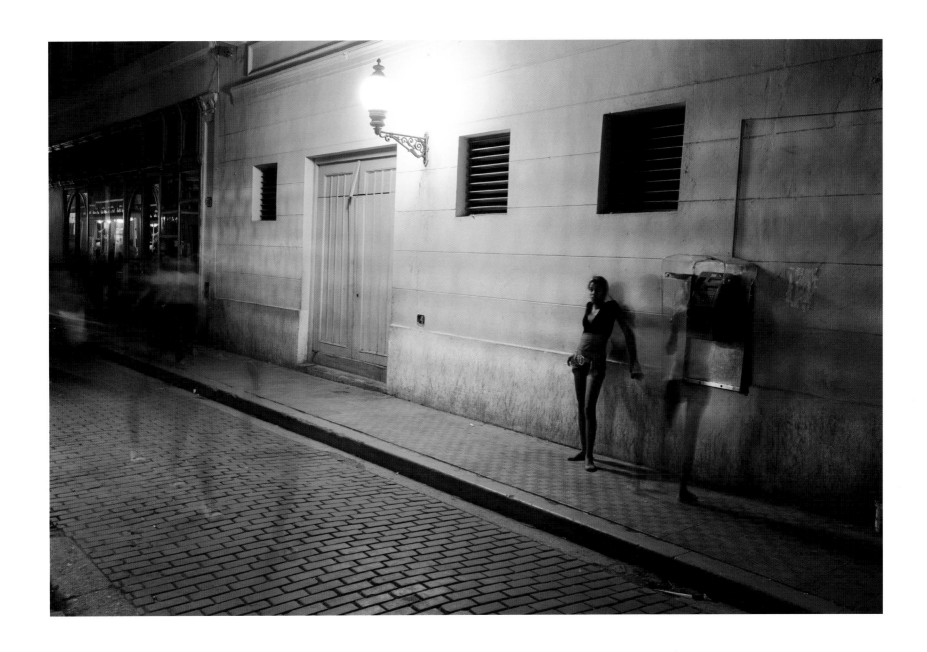

After sunset, under the streetlamps of Old Havana.

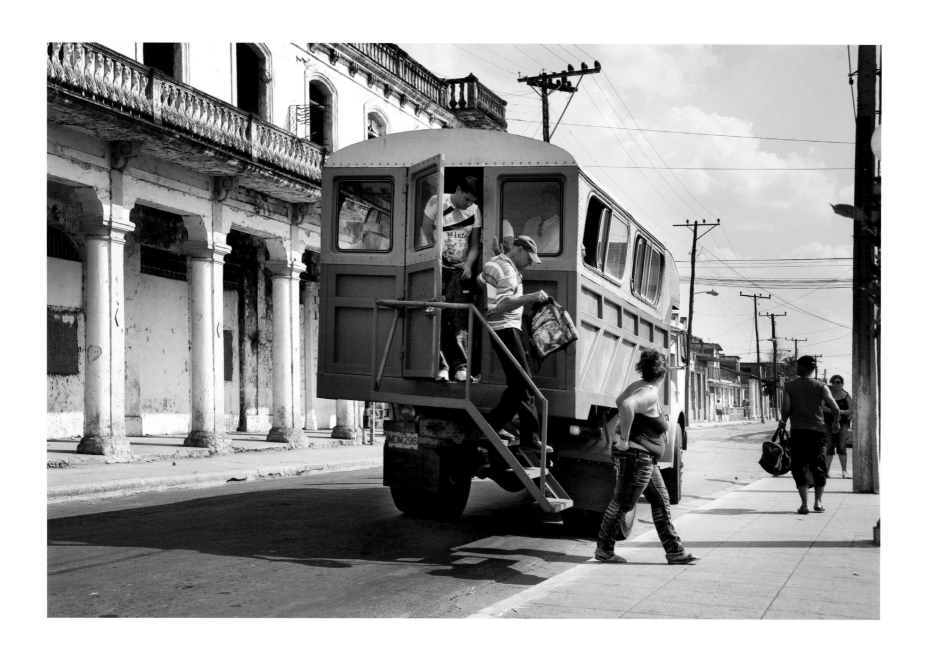

Pedro Betancourt, sometimes shortened as Betancourt, is a municipality and town in the Matanzas Province of Cuba. It is located in the center of the province, west of Jagüey Grande and east of Unión de Reyes. It was founded in 1833.

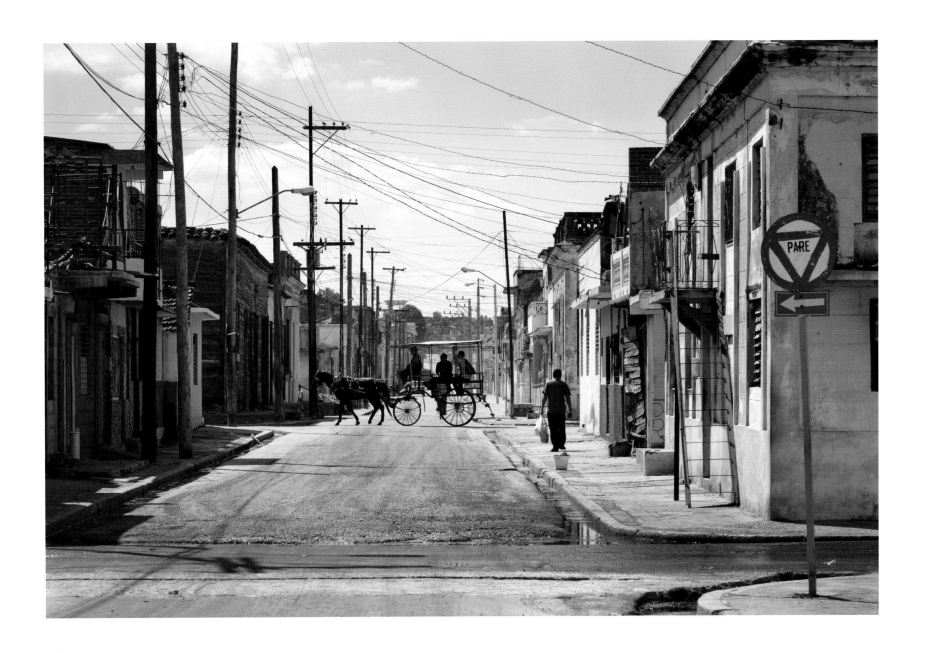

Horse-drawn buggies have been a fixture in Cuba since anyone can remember. But they became more popular after 1991, when the Soviet Union collapsed, ending the economic subsidies that kept Cuba afloat. Severe gasoline shortages crippled the island's public transportation system.

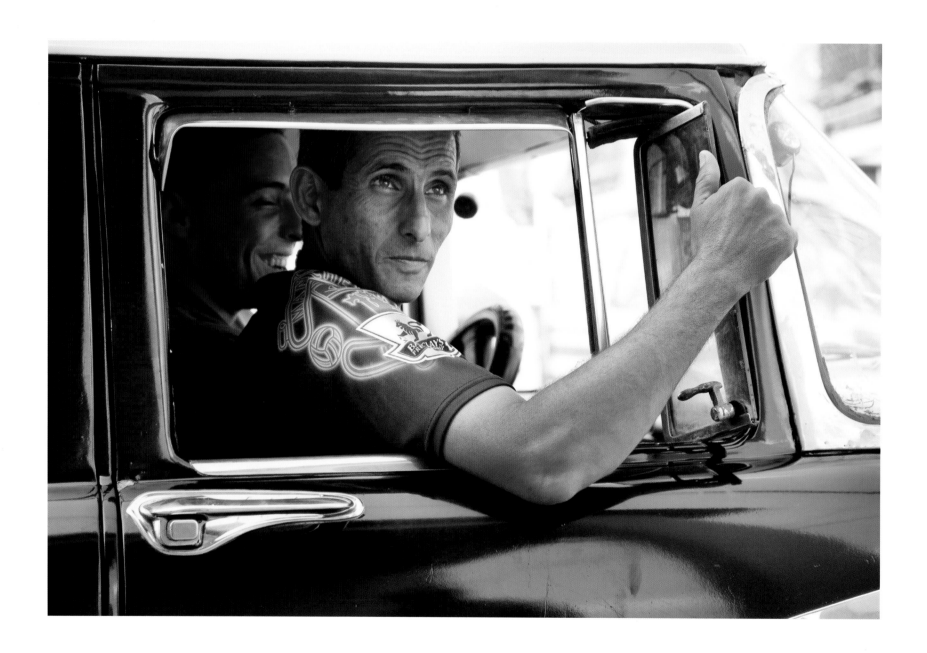

Yank tank or máquina are the words used to describe the many classic cars present in Cuba with an estimated 60,000 of them still driving the roads today. In 1962 a United States embargo against Cuba was introduced, effectively cutting trade between the two countries. Currently, the only way to keep these cars on the road today is by using Cuban ingenuity.

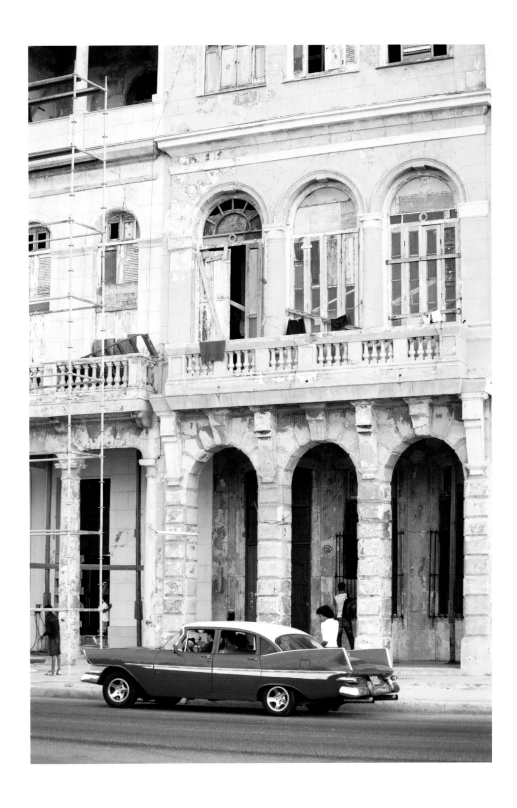

Cuba recently eased restrictions on car imports and acquisitions in the country.

PLAZA MAYOR

The Plaza Mayor in Trinidad, Cuba, is the historic centre of the town, declared a UNESCO World Heritage site in 1988.

The buildings surrounding the plaza (central square) date from the 18th and 19th centuries when trade in sugar from the nearby Valle de los Ingenios and the slave trade brought great riches to the area. Many of the buildings surrounding the plaza belonged to the wealthy landowners of the city.

When the trade in sugar diminished and the slave trade ended in the mid-19th century, Trinidad became 'a backwater' and little building work occurred until the 1950s. As a result, many of the historic buildings and streets were preserved, especially the grand colonial edifices in the immediate vicinity of the Plaza Mayor. Today, most of the former houses surrounding the square house museums.

The small sloping Plaza Mayor has gardens on a raised platform, with paths dividing it in quarters. The resulting four small garden beds are fenced off by white wrought-iron fences. Cobbled streets surround the square, separating it from the surrounding buildings. Wrought-iron lamp-posts, statues of English greyhounds, and columns with large terra-cotta finials decorate the plaza.

Above the plaza to the north-east stands the Church of the Holy Trinity (Iglesia Parroquial de la Santísima Trinidad). Construction began on the current church in the late 19th century and it was completed in 1892.

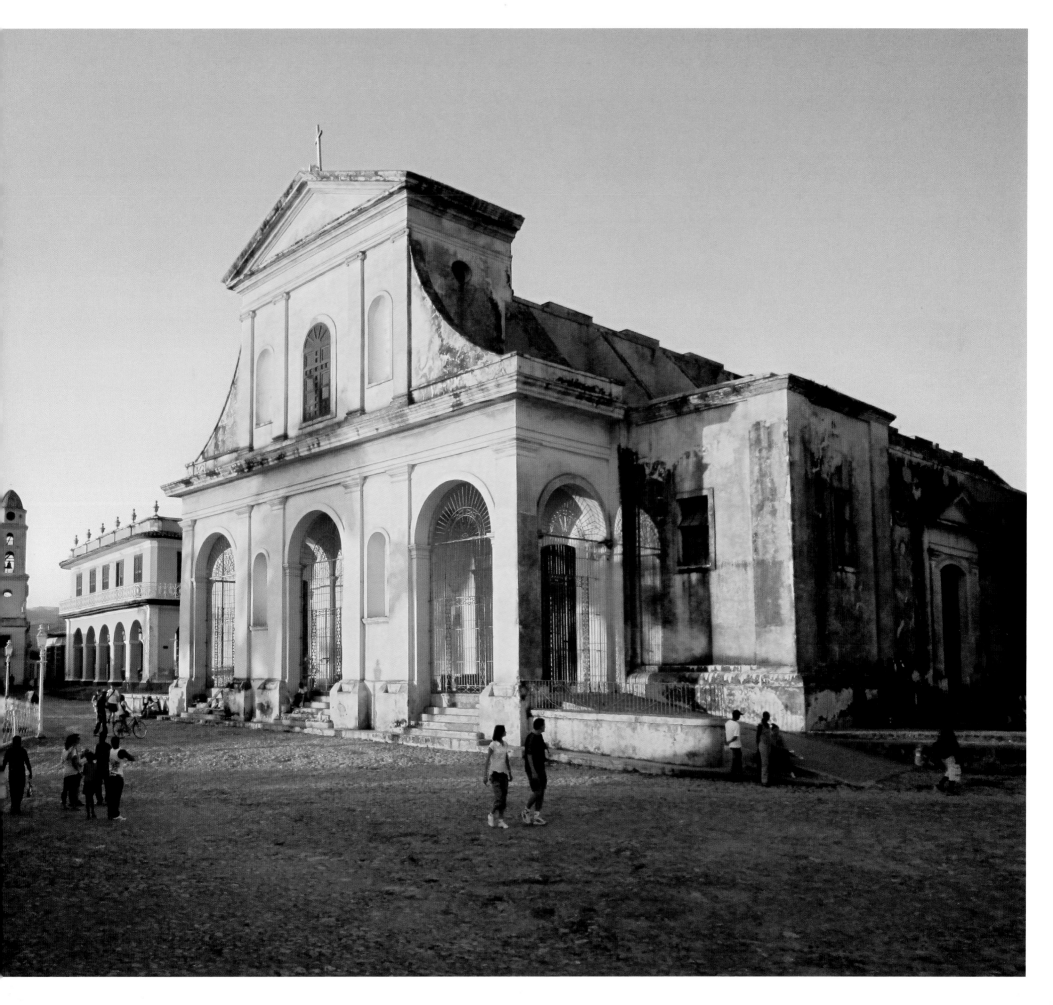

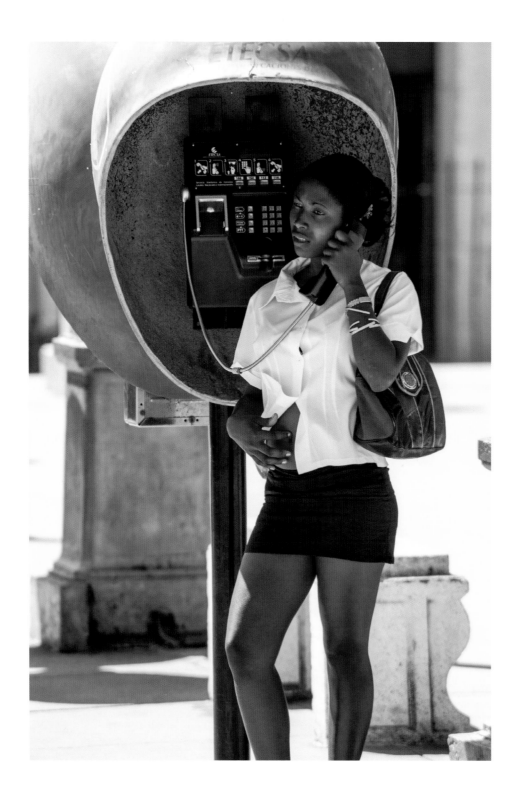

The Telecommunications Company of Cuba is working on the installation
of new public telephones.

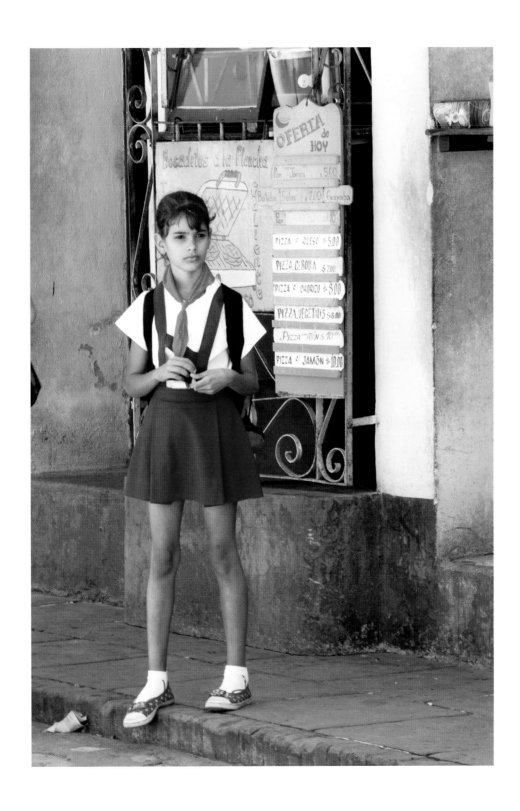

In Cuba, primary education gets great priority and it's system is highly ranked. Going to the schools is a must for the children.

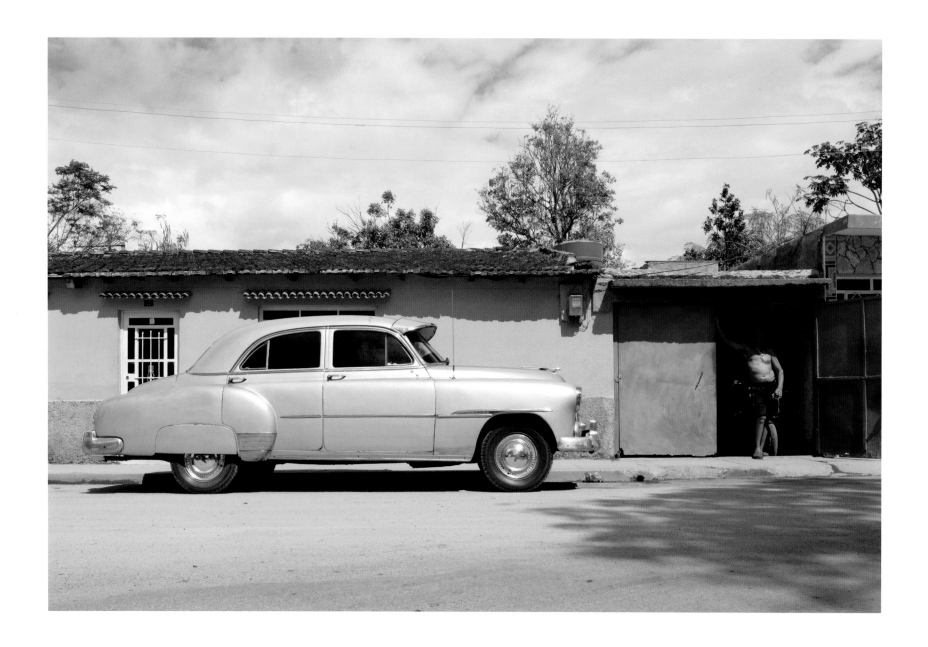

The only American cars that can be purchased for private use in Cuba are those that were previously registered for private use and acquired before the revolution. However, if the owner doesn't have the proper paper work called a "traspaso", the vehicle cannot be legally sold. American cars that were present, at the time of the embargo, have been preserved through loving care and ingenuity.

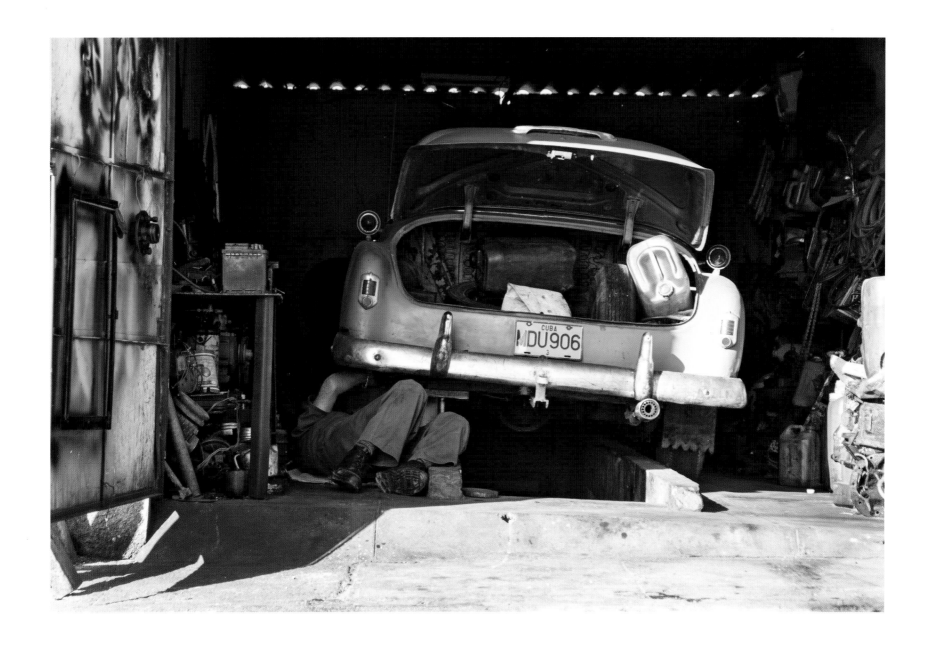

Due to the presence of a past strong Cuban middle-class, classic cars have been the standard, rather than an exception in Cuba. Due to the constant good care, many remain in good working order only because Cuban people are able to adapt to a diminishing source of parts to keep the vehicles running.

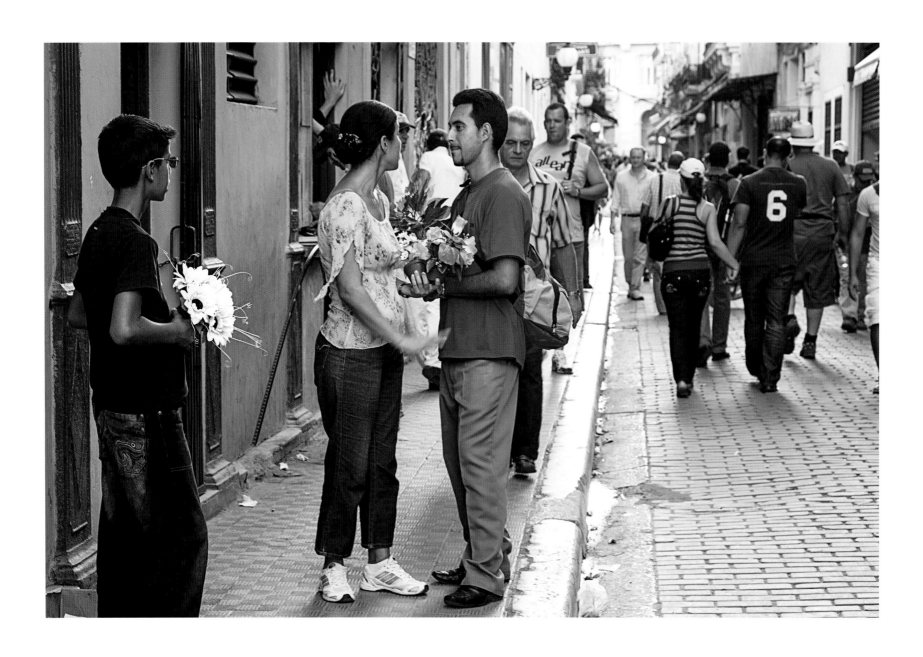

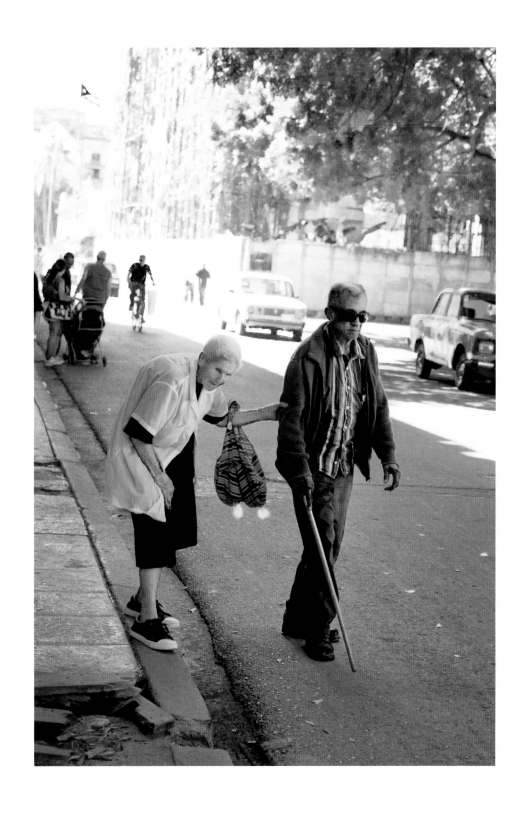

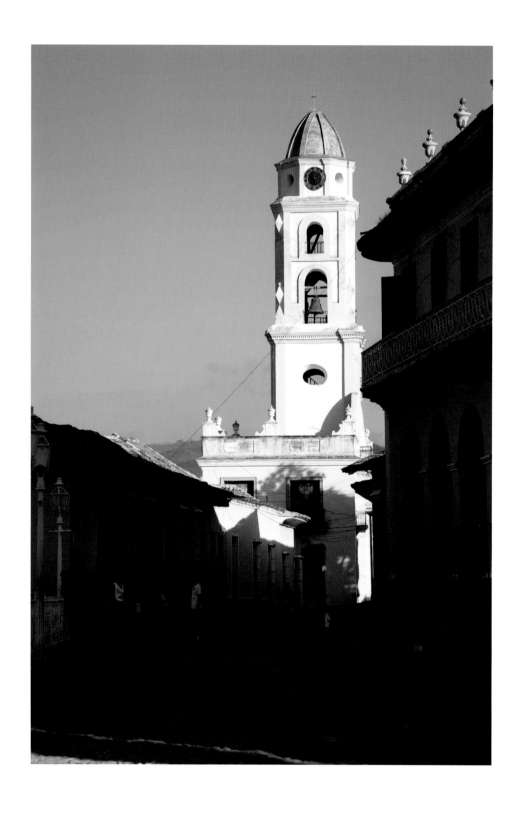

Most Holy Trinity church was built between 1755 and 1783 as a temple for the adjoining hospital/hospice for priests.

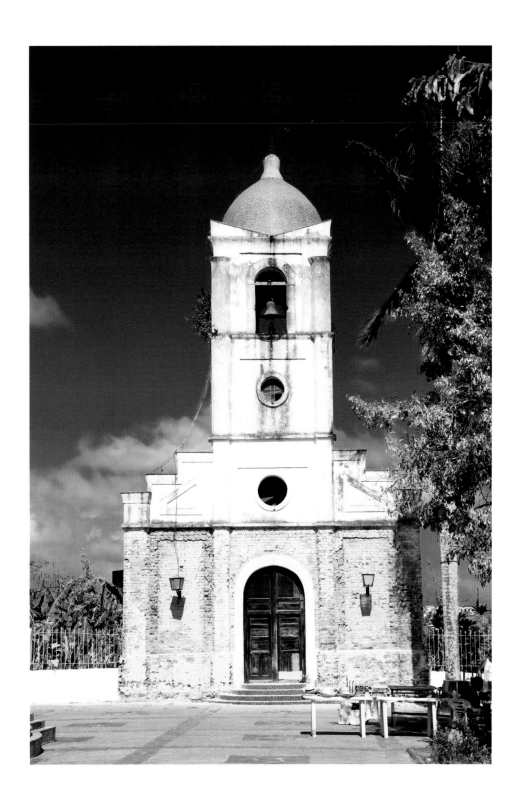

Iglesia del Sagrado Corazon de Jesus had been restored, however, a subsequent hurricane did damage to it and parts of it are destroyed.

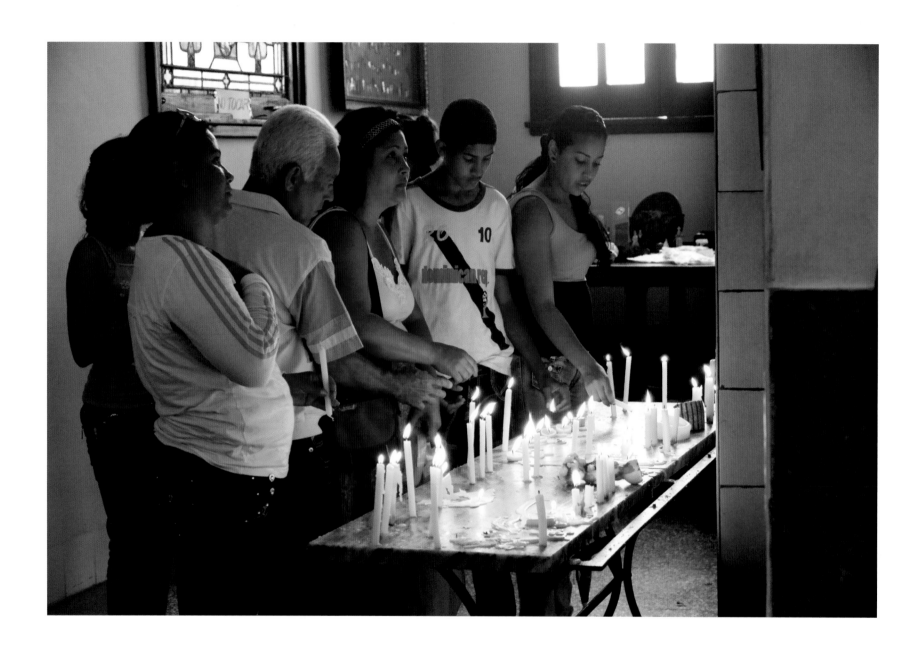

The story behind the La Virgen de la Caridad del Cobre, began around 1612. Two brothers, Rodrigo and Juan de Hoyos, and a black slave child, Juan Moreno, set out to the Bay of Nipe for salt. They are traditionally called the "three Juans". They needed the salt for the preservation the meat at the Barajagua slaughter house, which supplied the workers and inhabitants of Santiago del Prado, now known as El Cobre. While out in the bay, a storm arose, rocking their tiny boat violently with ongoing waves. Juan, the slave, was wearing a medal with the image of the Virgin Mary. The three men began to pray for her protection. Suddenly, the skies cleared, and the storm was gone.

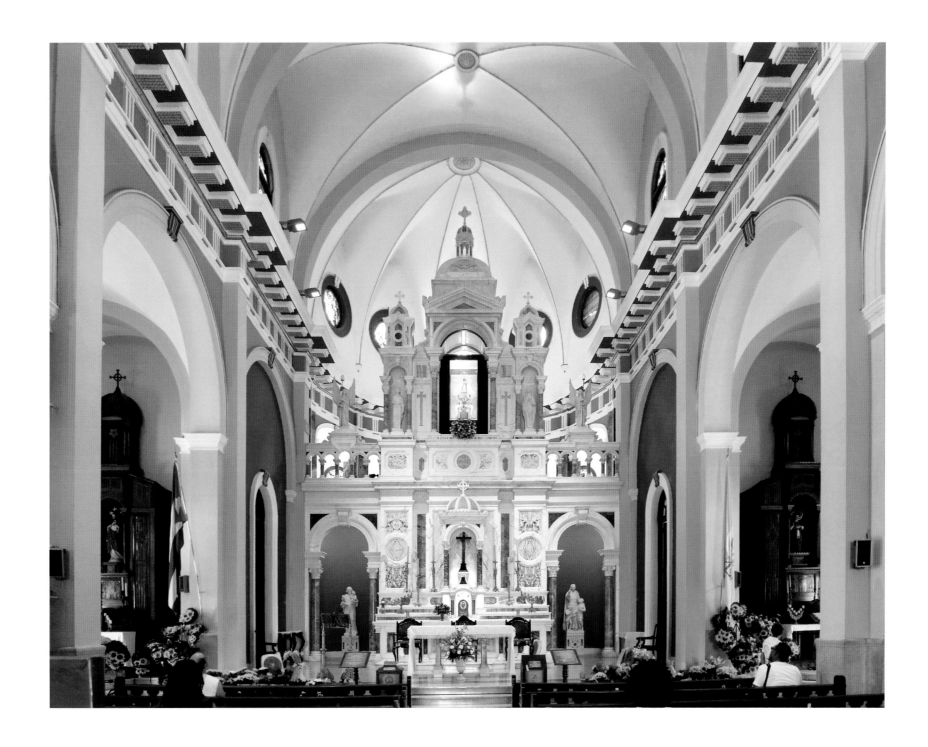

They rowed towards it as the waves brought it towards them. At first they mistook it for a bird, but quickly saw that it was what seemed to be a statue of a girl. At last they were able to determine that it was a statue of the Virgin Mary holding the child Jesus on her LEFT arm and holding a gold cross in her RIGHT hand. The statue was fastened to a board with an inscription saying "Yo Soy la Virgen de la Caridad" or "I am the Virgin of Charity." The statue was dressed with real cloth and the Virgin had real hair and skin of a mixed woman. Much to their surprise, the statue remained completely dry while afloat in the water.

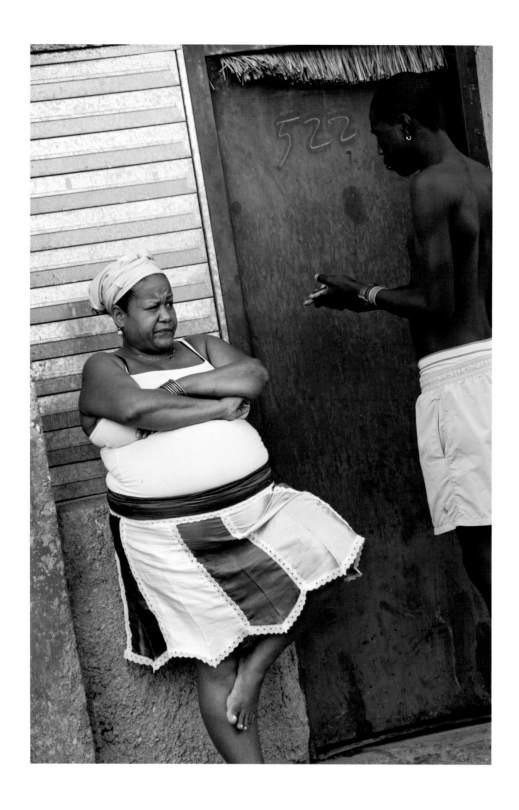

66 Mother and Son, Barrio

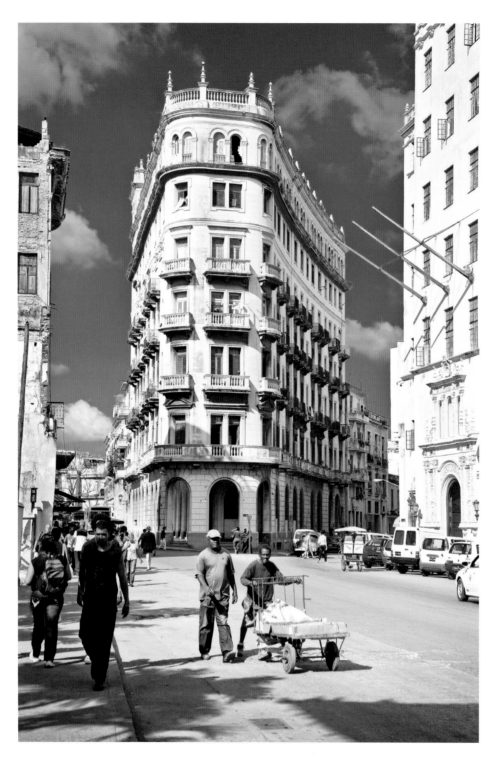

Chinese immigration to Cuba started in 1847 when Cantonese contract workers were brought to work in the sugar fields, bringing the religion of Buddhism with them. Hundreds of thousands of Chinese workers were brought in to replace and work alongside African slaves.

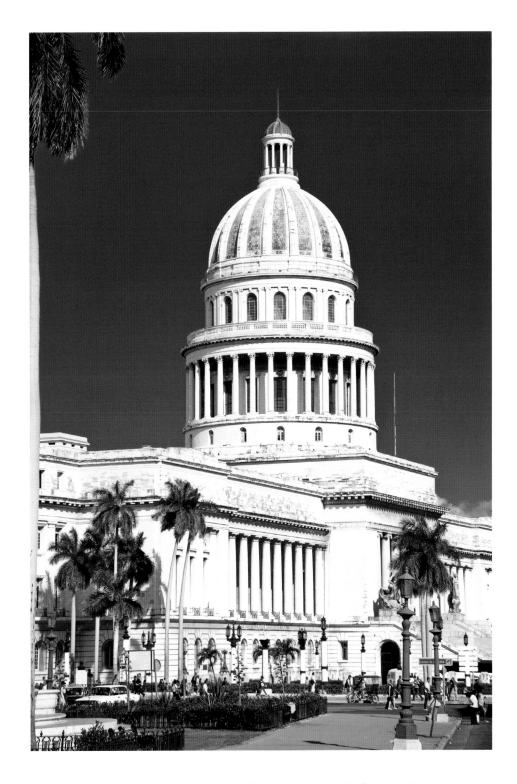

El Capitolio, in Havana, was the seat of government until after the Cuban Revolution in 1959, and is now home to the Cuban Academy of Sciences. It also houses the world's third largest indoor statue.

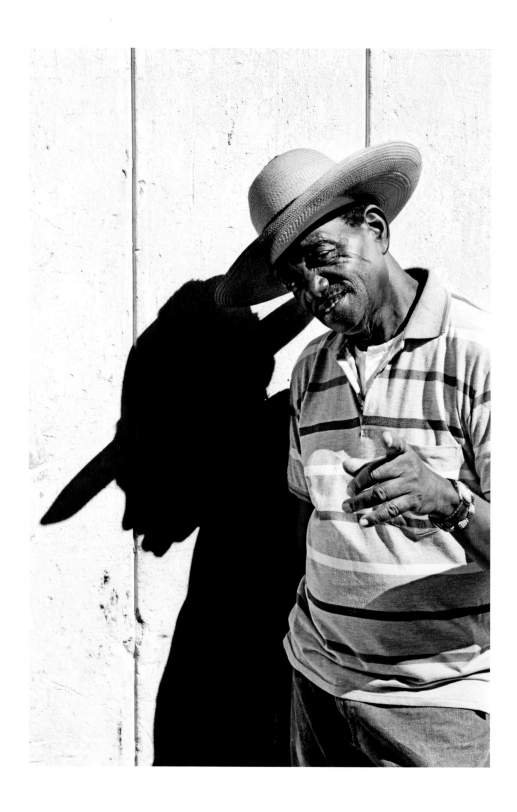

Eladio "Don Pancho" Terry, violinist and Cuba's leading player of the chekeré.

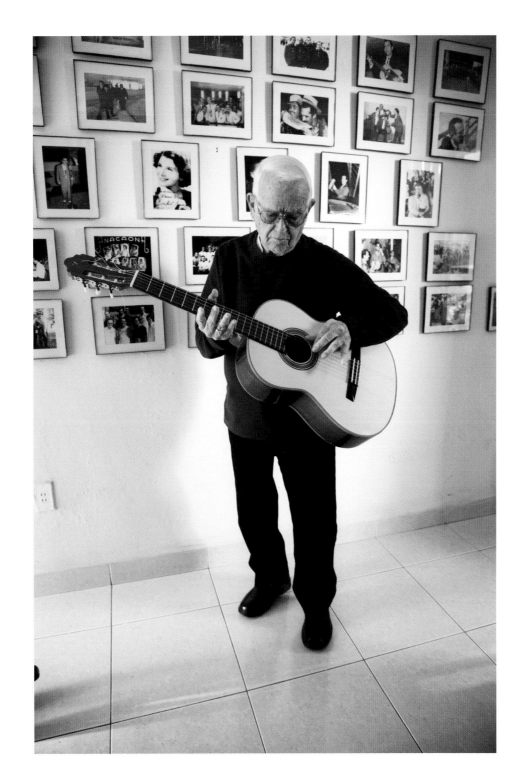

Leader of the Senén Suárez Band, which in 1952 would record the emblematic "Guaguancó callejero". He has a vast catalogue, including his classic bolero "Eres sensacional" (You're sensational) –that would become a hit interpreted by Alfonsín Quintana. He also wrote for Celia Cruz, Benny Moré, Fernando Alvarez, Bienvenido Granda, Nelson Pinedo, Carlos Argentino, Oscar D´León, the Sonora Ponceña, the Aragón Orchestra, and so many others.

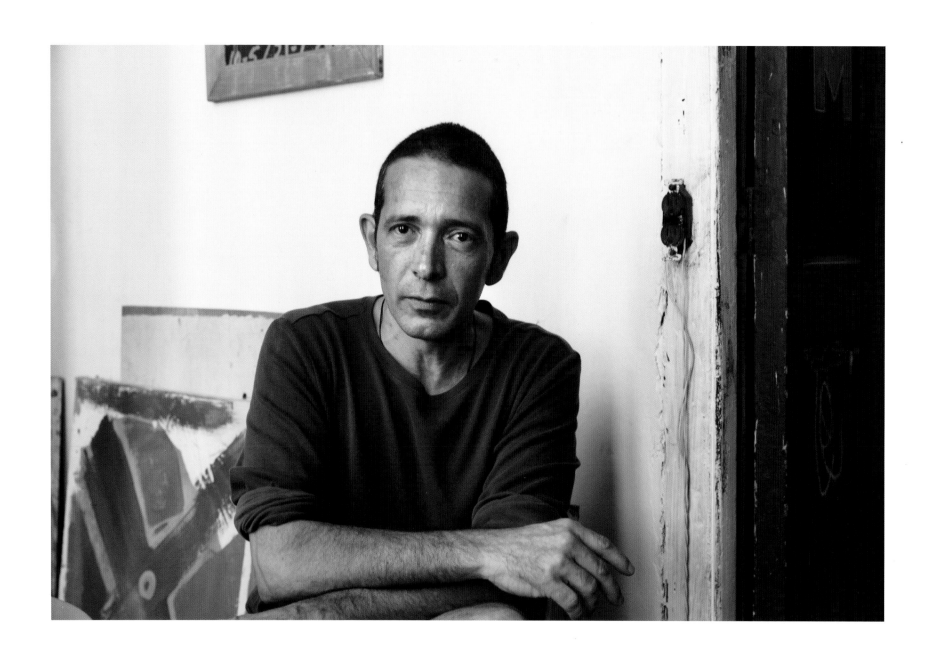

Omar Perez's essay, "The Intellectual and Power in Cuba", appears at the beginning of this book.

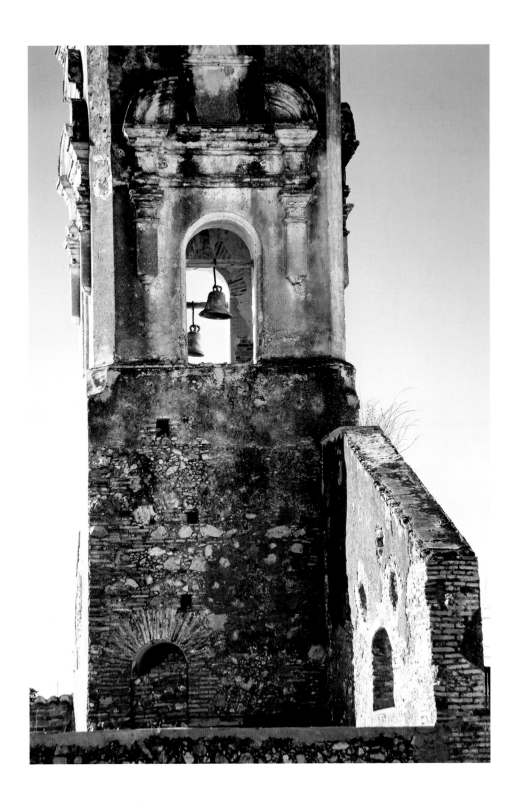

The ruined shell of this church (1812) defiantly remains. Looming like a time-worn ecclesiastical stencil, it looks ghostly after dark.

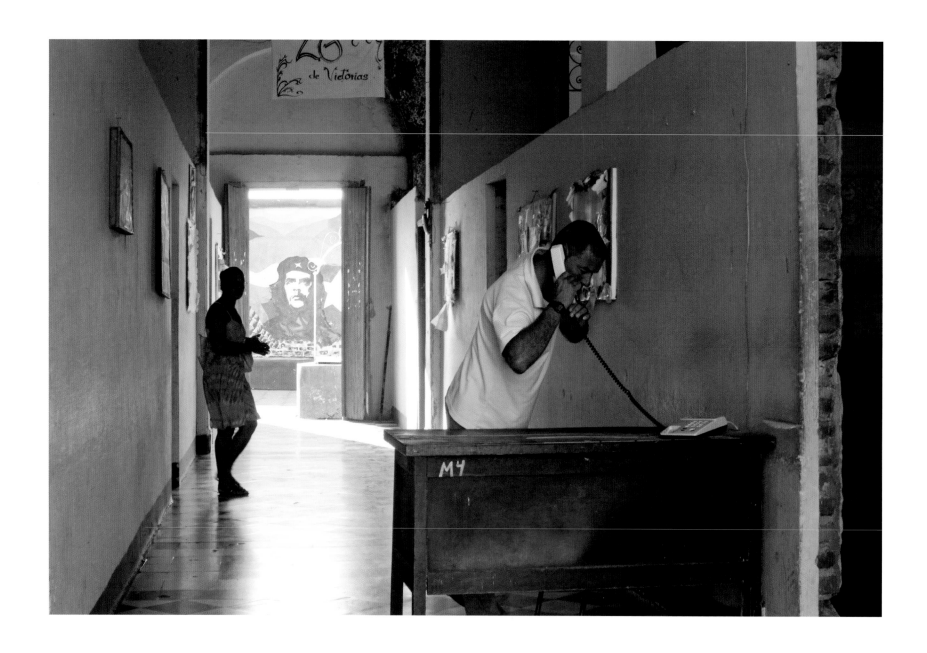

Following the basic restructuring and reopening of Cuban schools, the new government focused on the huge literacy problem the country faced. Literacy centers were opened and to further reach out to all, teens and other volunteers were sent out to the countryside to teach their fellow Cubans how to read.

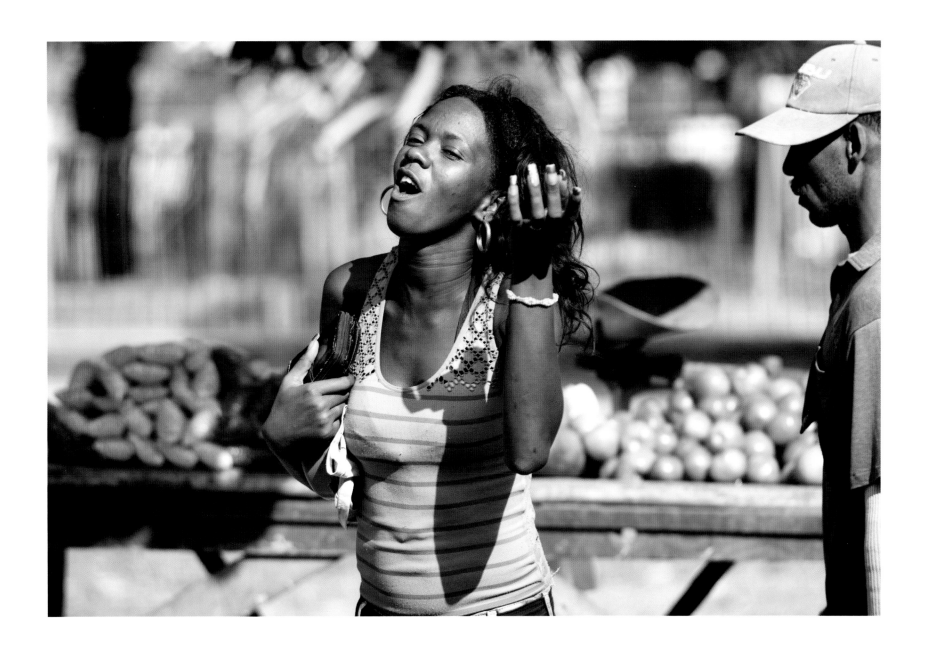

Alamar is the birthplace of cuban hip-hop. A seaside project on the north shore, Alamar became a place of new influences from other Latin countries and Europe. Comprised of many cultures, this generation of young Cubans grew up listening to FM radio stations from the US, where Rock and Hip-hop filled their minds and imaginations with something fresh, new, and different.

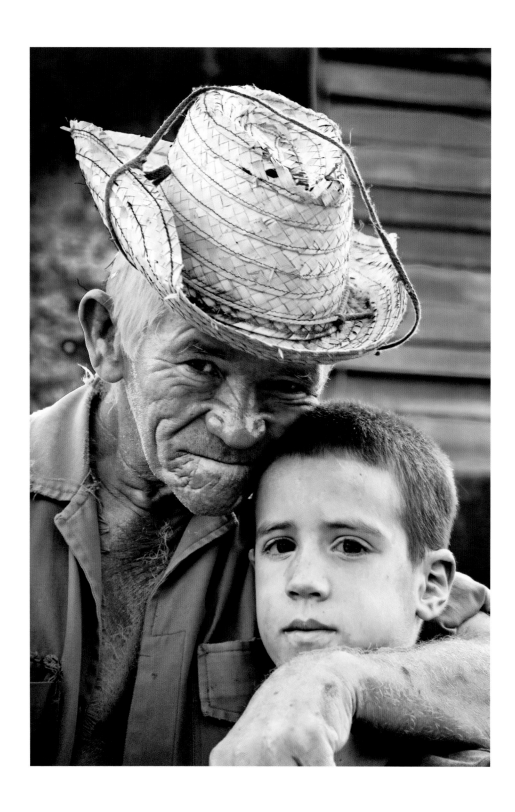

76 Grandfather and Grandson, San Diego de los Banos

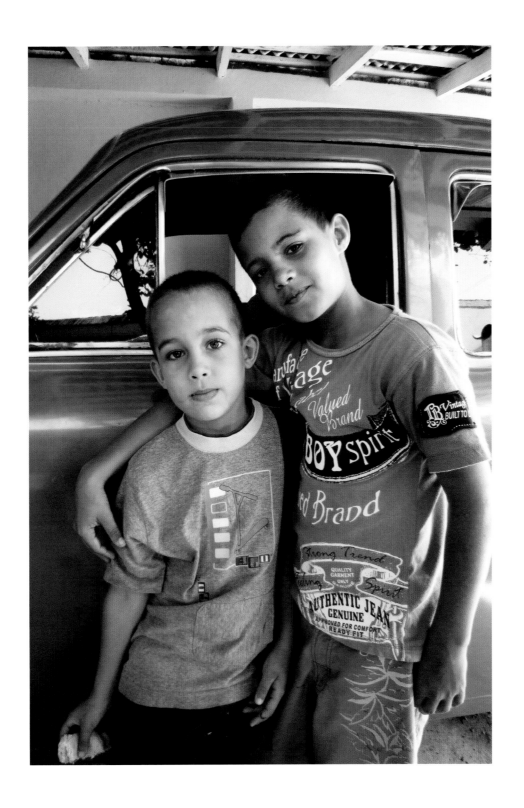

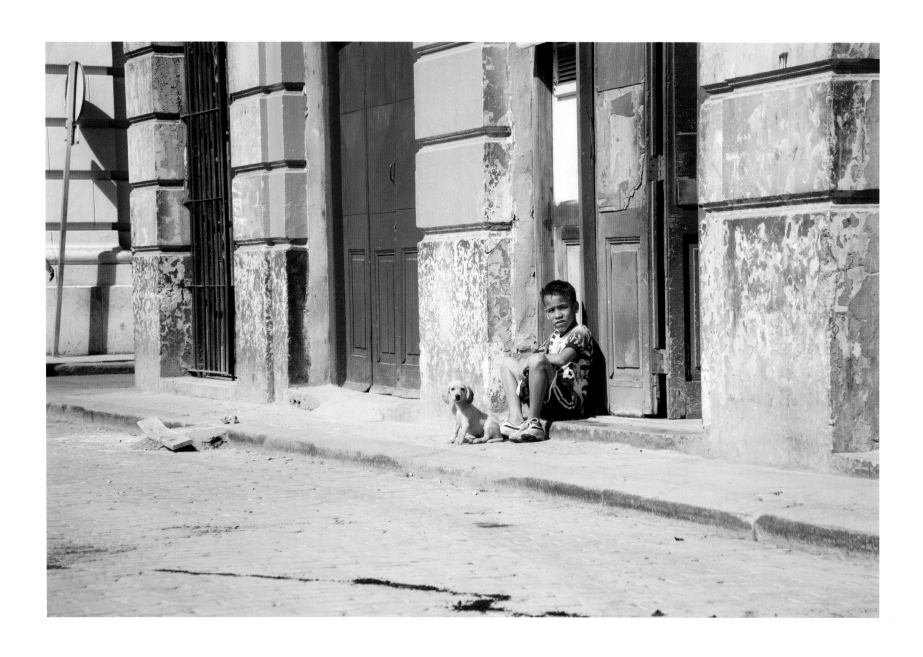

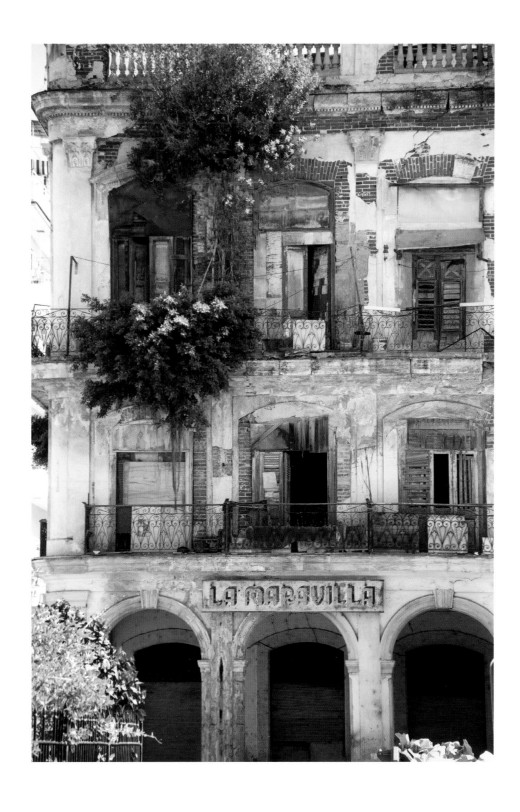

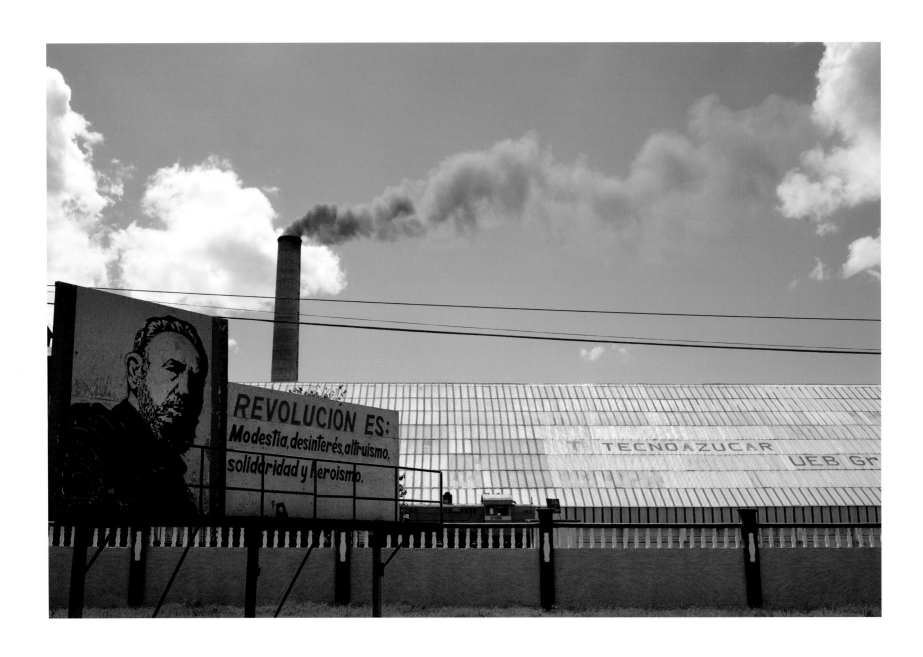

"Revolution is: modesty, altruism, selflessness, solidarity and heroism" Fidel Castro.

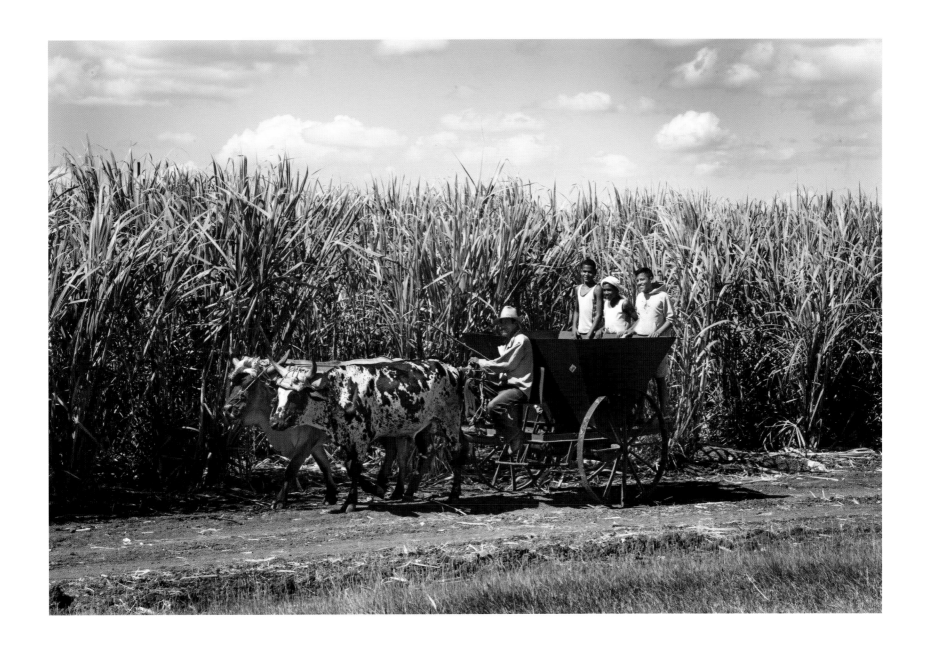

Sugar is the principal agricultural economy. The government is trying to breathe new life into the once-iconic crop that has fallen on hard times.

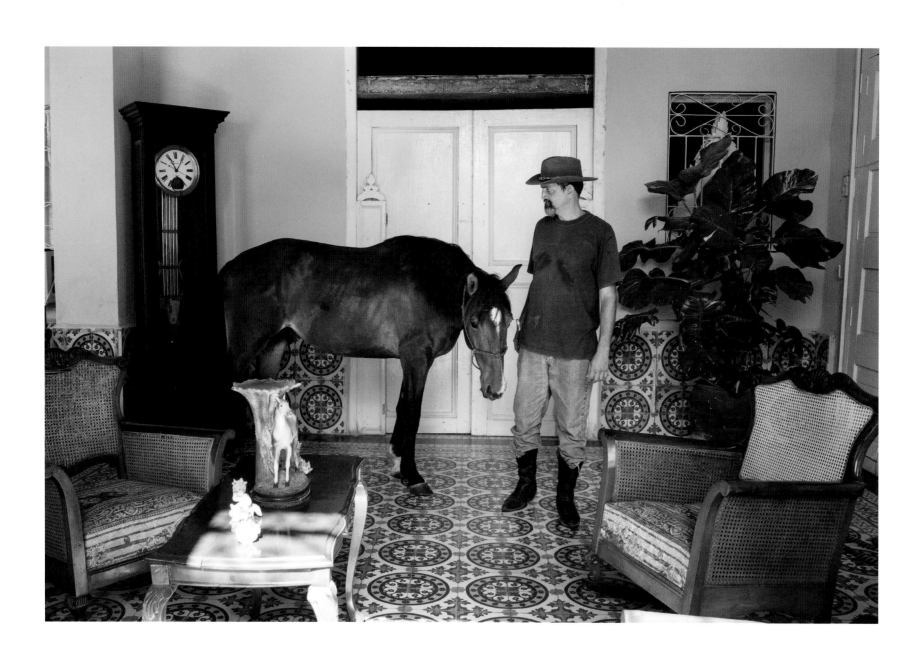

82 Julio Munez, Horse Whisperer and Photographer, Trinidad

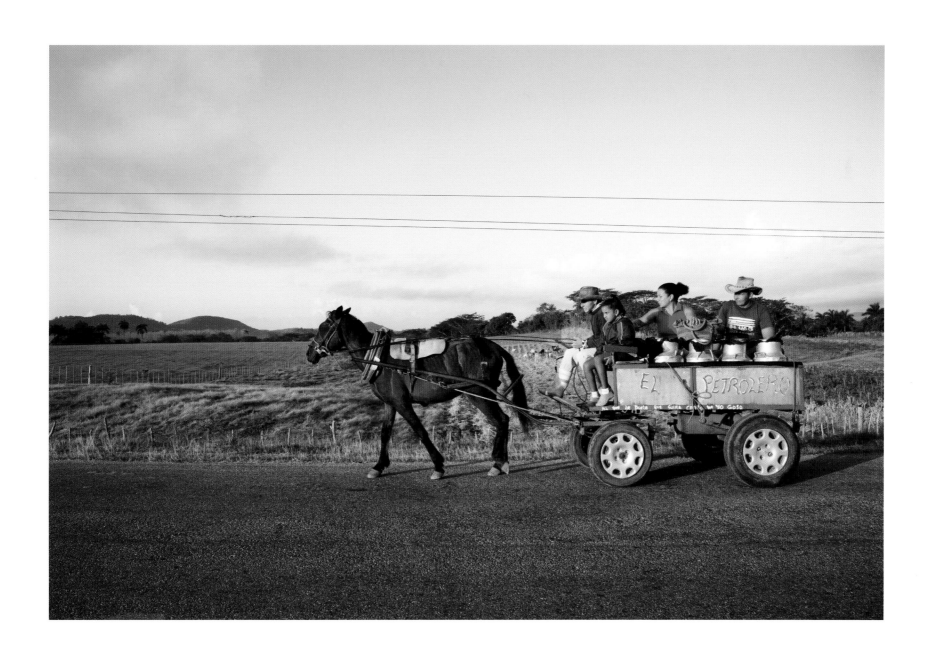

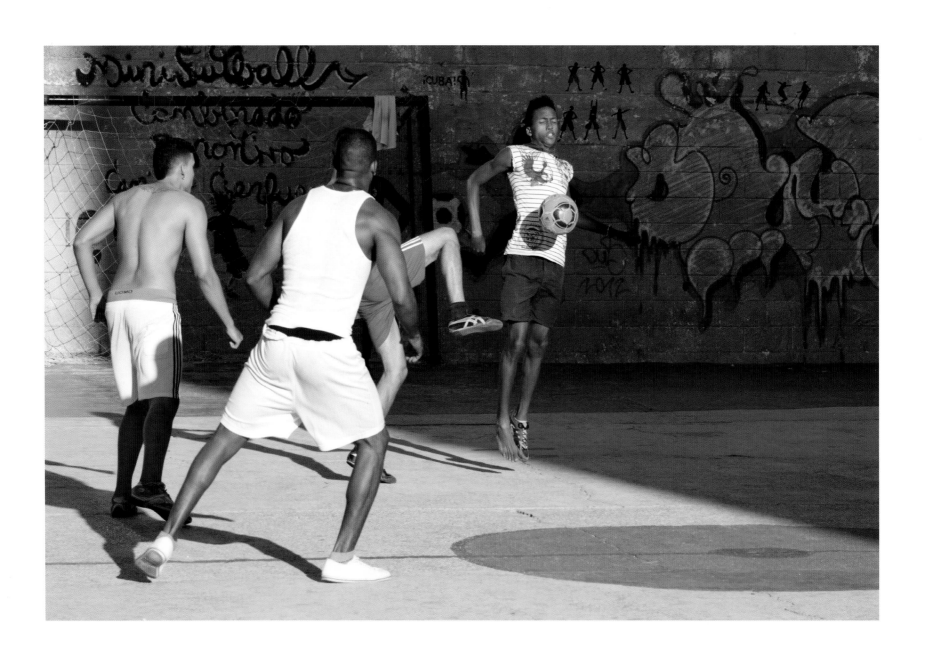

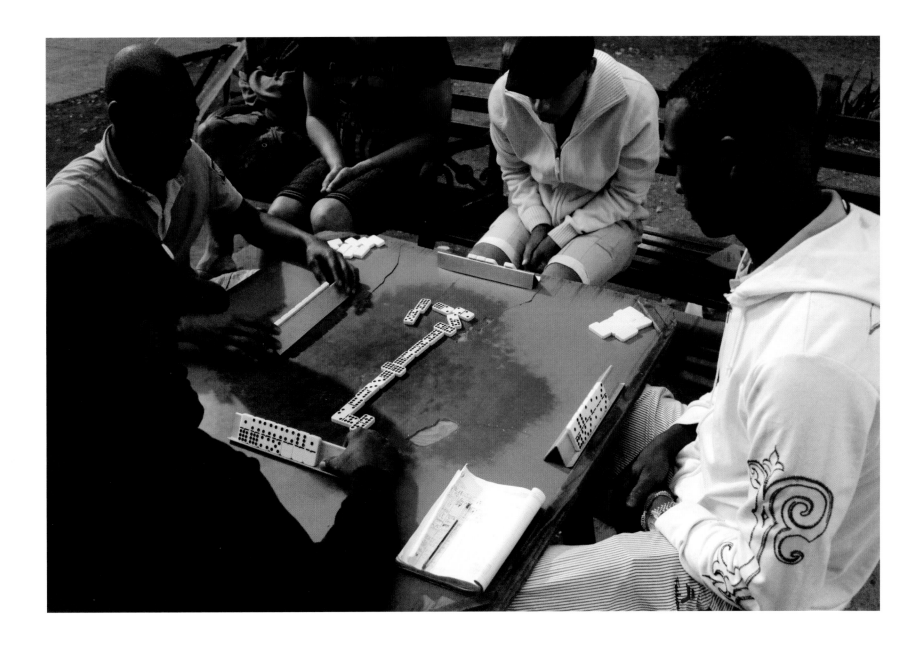

The game of dominoes is the national game of Cuba. For many, the game is a daily social event that combines competition with camaraderie. You frequently see people playing games in parks and other public areas. Older Cuban gentlemen, many smoking cigars and wearing the traditional guayabera shirt, keep several tables in a constant state of activity.

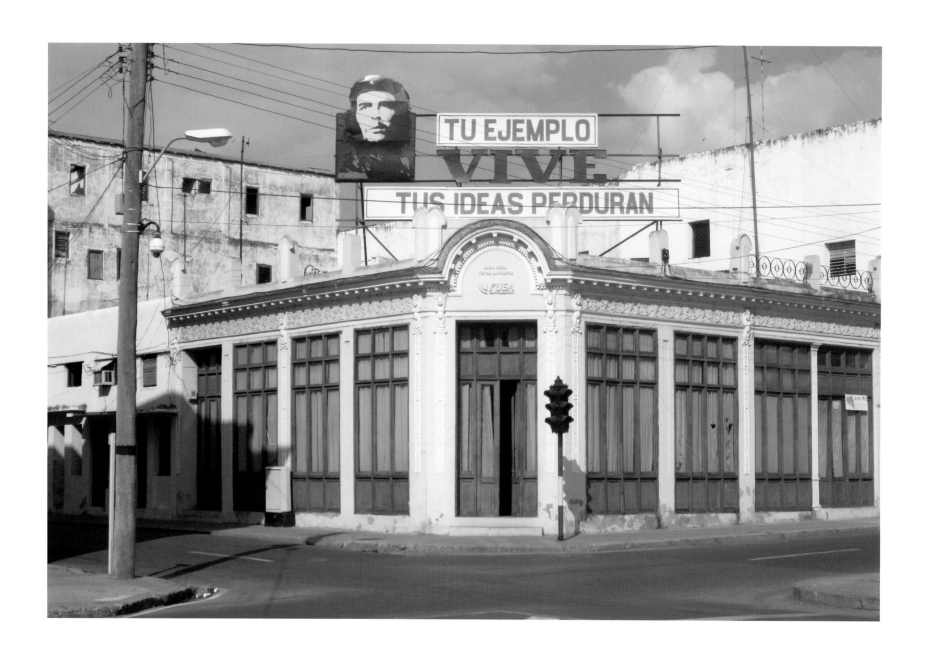

"Live by Example, Your Ideas Endure", Che Guevara

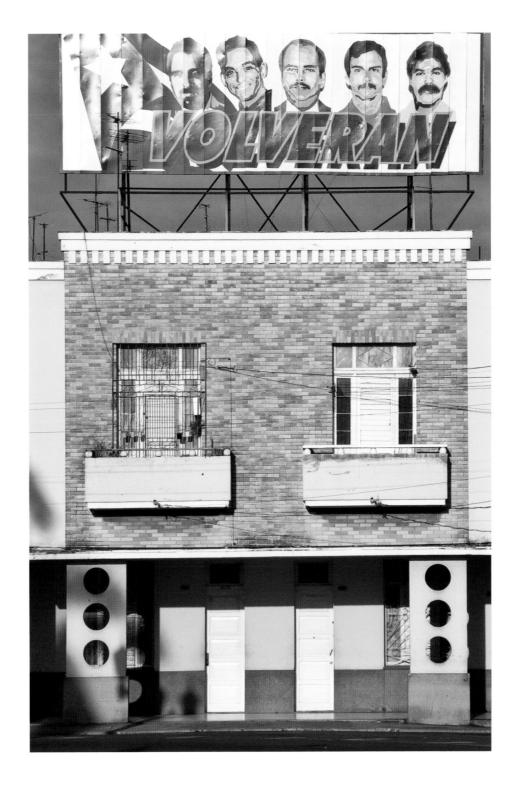

The Cuban Five, also known as the Miami Five (Gerardo Hernández, Antonio Guerrero, Ramón Labañino, Fernando González, and René González) are five Cuban intelligence officers convicted in Miami of conspiracy to commit espionage.

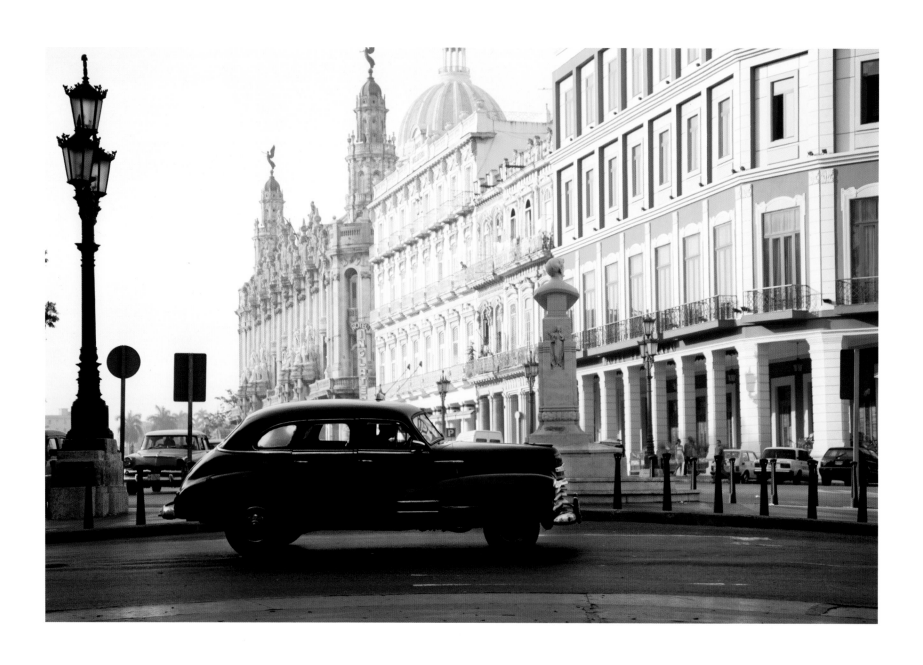

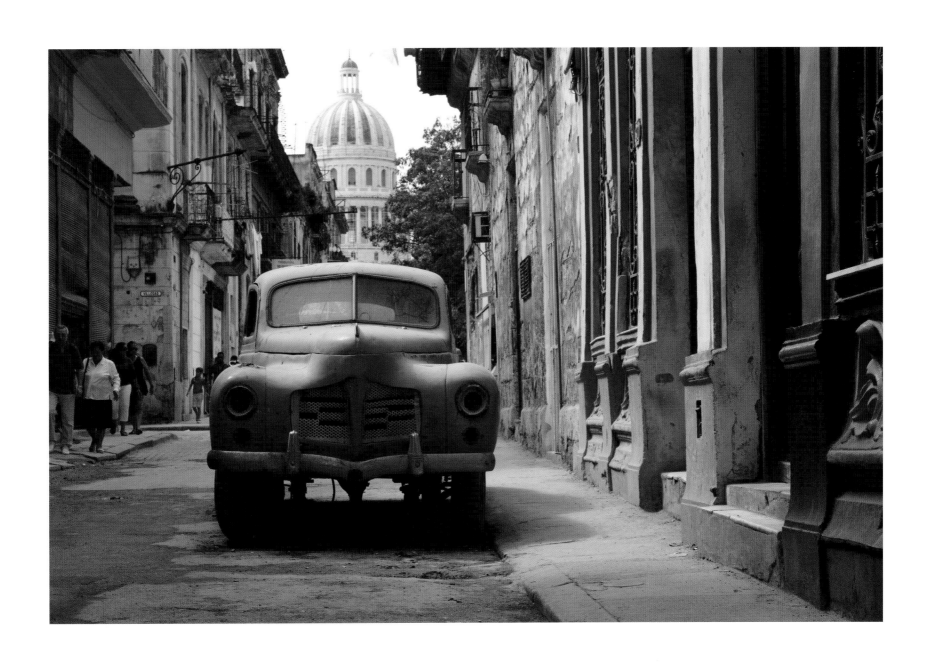

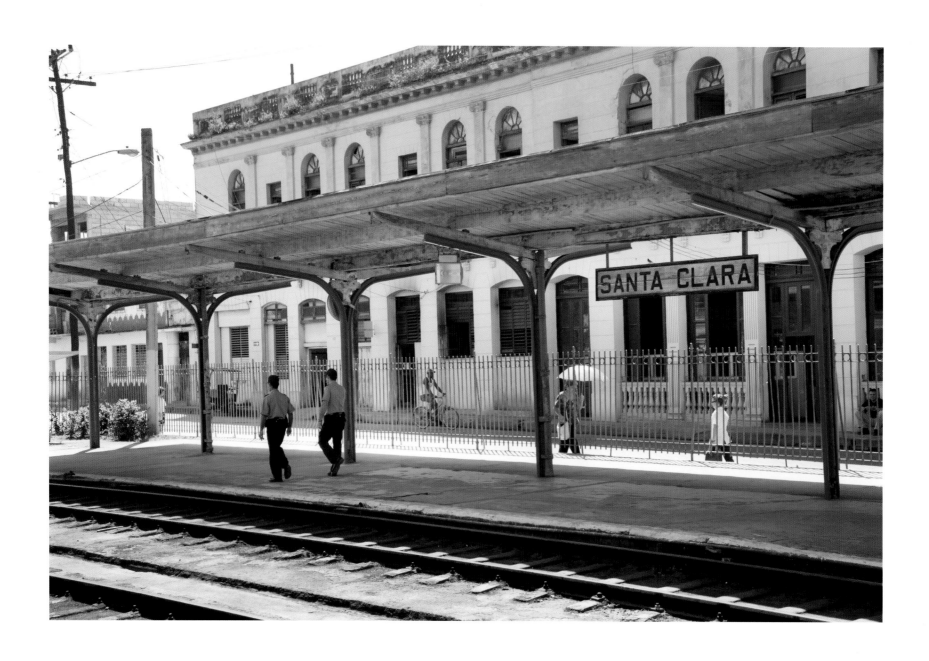

Santa Clara was the site of the last battle in the Cuban Revolution in late 1958. There were two guerrilla columns that attacked the city, one led by Ernesto Che Guevara and the other led by Camilo Cienfuegos. Guevara's column first captured the garrison at Fomento. Then, using a bulldozer, Guevara's soldiers destroyed railroad tracks and derailed a train full of troops and supplies sent by Batista. At the same time, Cienfuegos's column defeated an army garrison at the Battle of Yaguajay not far from town.

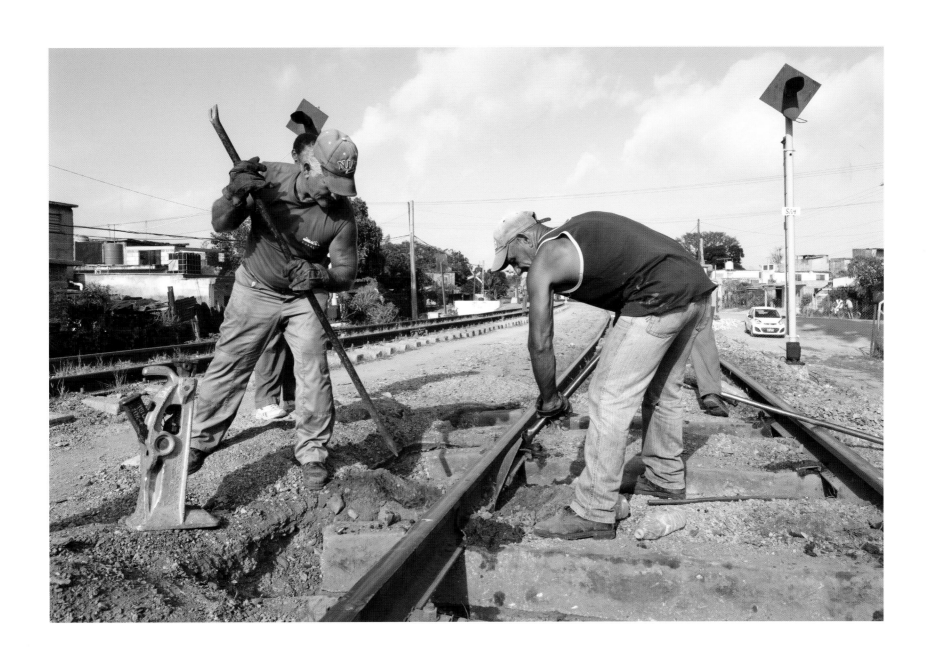

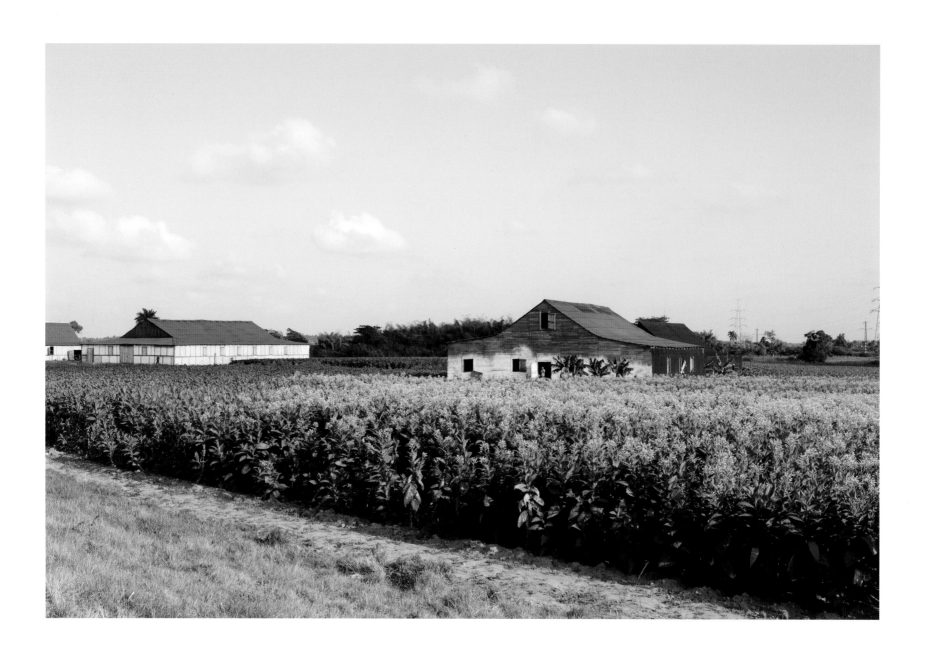

Cuba has the second largest area planted with tobacco of all countries world wide. Tobacco production in Cuba has remained about the same since the late 1990s. Cigars are a famous Cuban product worldwide and almost the whole production is exported. The center of Cuban tobacco production is the Pinar del Río Province.

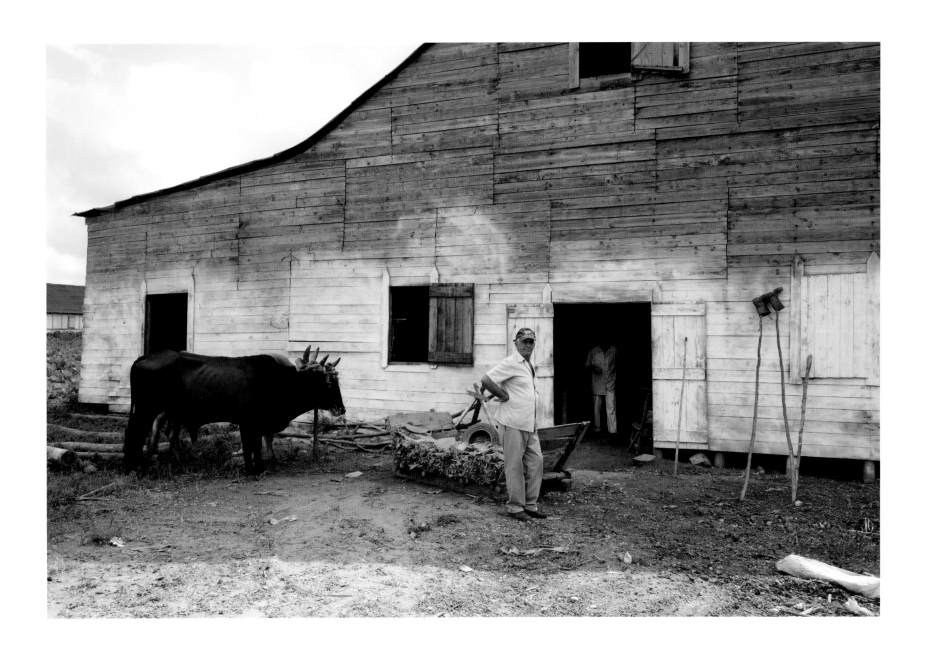

Agriculture has played an important part in the economy for several hundred years.

VINALES VALLEY

The Vinales valley is encircled by mountains and its landscape is interspersed with dramatic rocky outcrops. It has an outstanding karst landscape in which traditional methods of agriculture (notably tobacco-growing) have survived unchanged for several centuries. The region also preserves a rich vernacular tradition in its architecture, crafts and music. The quality of this cultural landscape is enhanced by the vernacular architecture of its farms and villages, where a rich multi-ethnic society survives, illustrating the cultural development of the islands of the Caribbean, and of Cuba.

Tobacco and other crops are cultivated on the bottom of the valley, mostly by traditional agriculture techniques. Many caves dot the surrounding hill-faces. The conspicuous cliffs rising like islands from the bottom of the valley are called mogotes.

Most of the buildings scattered over the plain are simple; they are built using local and natural materials, and are used as homes or family farms. The village of Vinales, strung out along its main street, has retained its original layout, and there are many interesting examples of colonial architecture. The valley is home to an original culture, a synthesis of contributions from indigenous peoples, Spanish conquerors and black slaves.

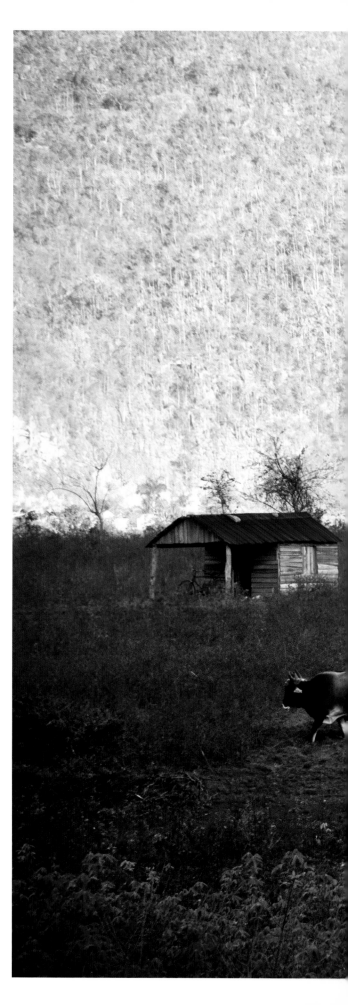

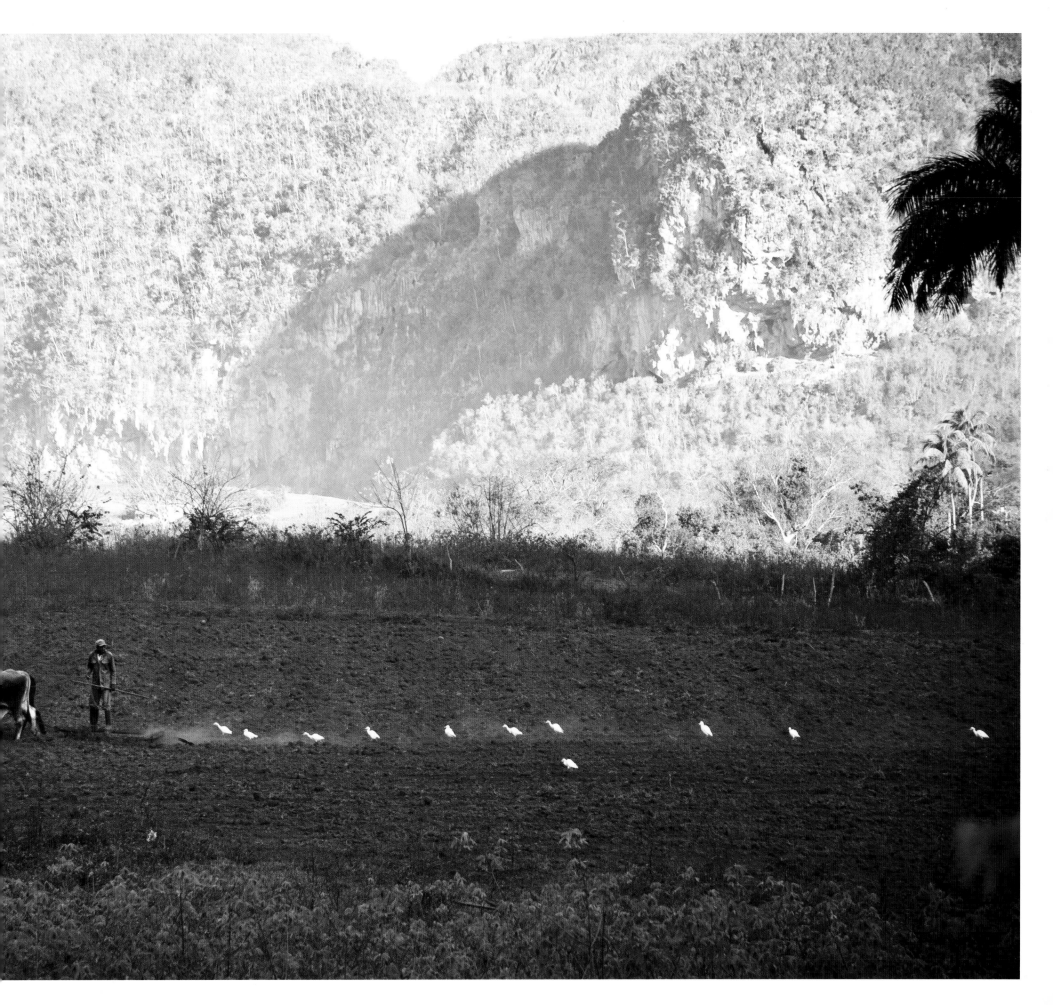

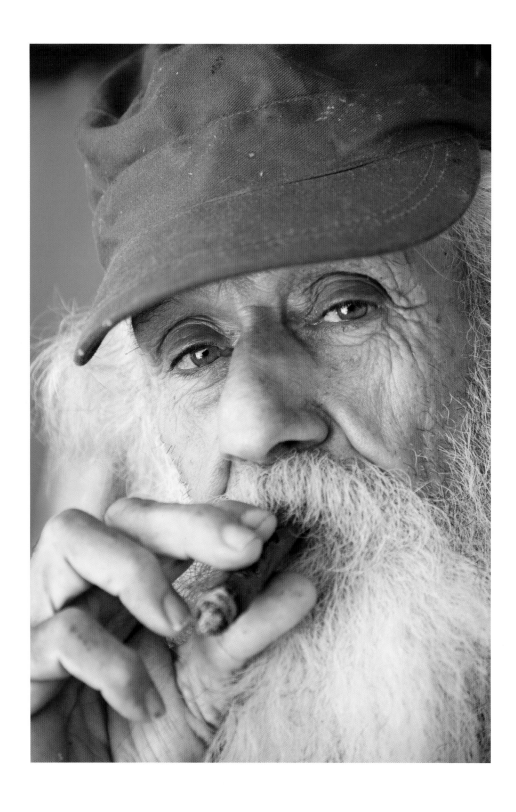

Self-taught painter. Julian Espinosa, an untrained, "primitive" artist known as "Wayacon" "little frog".

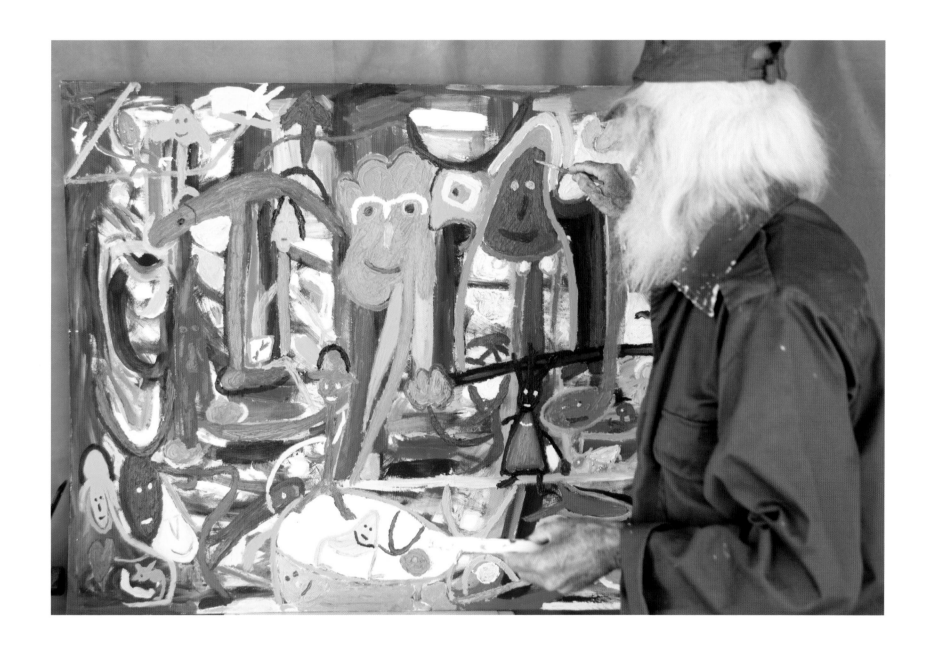

Wayacon (Julian Espinosa) is an intensely liberated man who is not restrained by notions that limit most artists. He is as likely to paint on paper or canvas as he is to use a shirt or a pair of paints as his surface. Some may say his work looks childlike. Yet no child would create art with this intensity and depth of focus. There is a directness to his efforts that is always fresh and unencumbered.

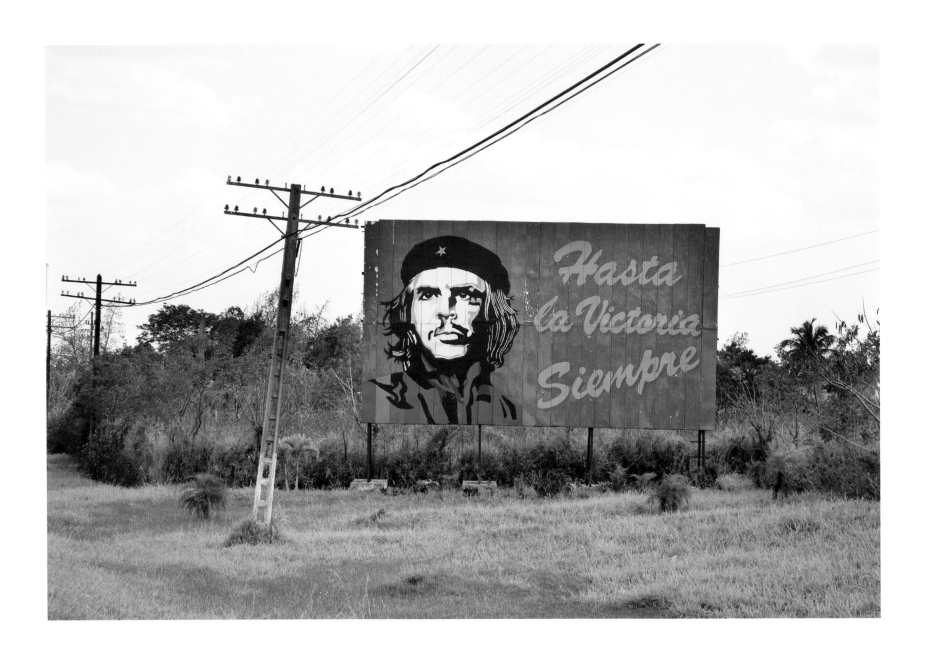

"Hasta Siempre, Comandante", or simply "Hasta Siempre"w, is a 1965 song by Cuban composer Carlos Puebla. The song's lyrics are a reply to revolutionary Che Guevara's farewell letter when he left Cuba, in order to foster revolution in the Congo and later Bolivia, where he would be captured and executed. The lyrics recount key moments of the Cuban Revolution, describing Che Guevara and his role as a revolutionary commander. The song became iconic after Guevara's death, and many left-leaning artists did their own cover versions of the song afterwards.

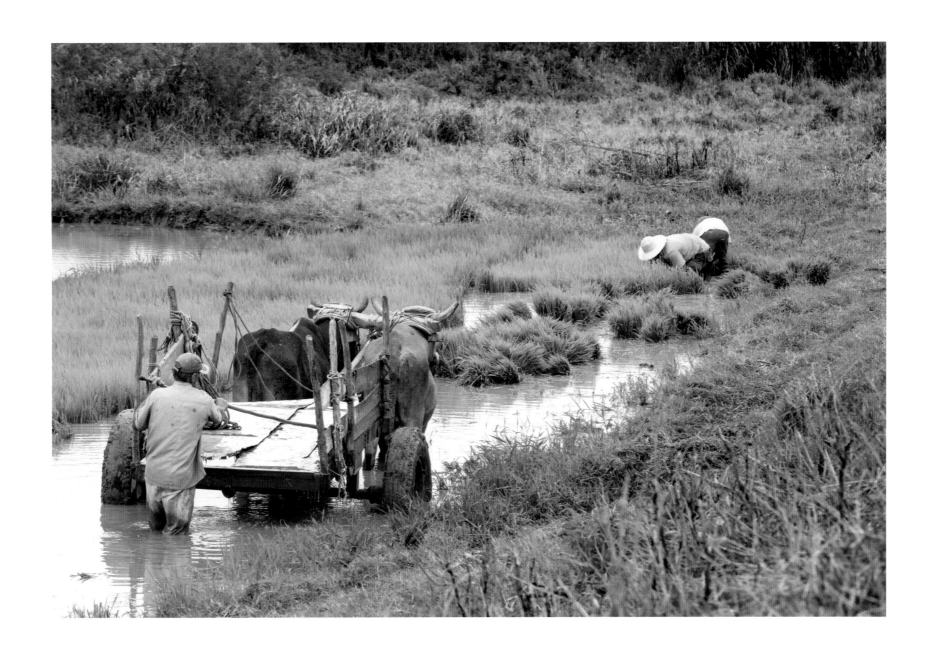

Rice in Cuba is mostly grown along the western coast. There are two crops per year. The majority of the rice farms are state-farms or belong to co-operatives.

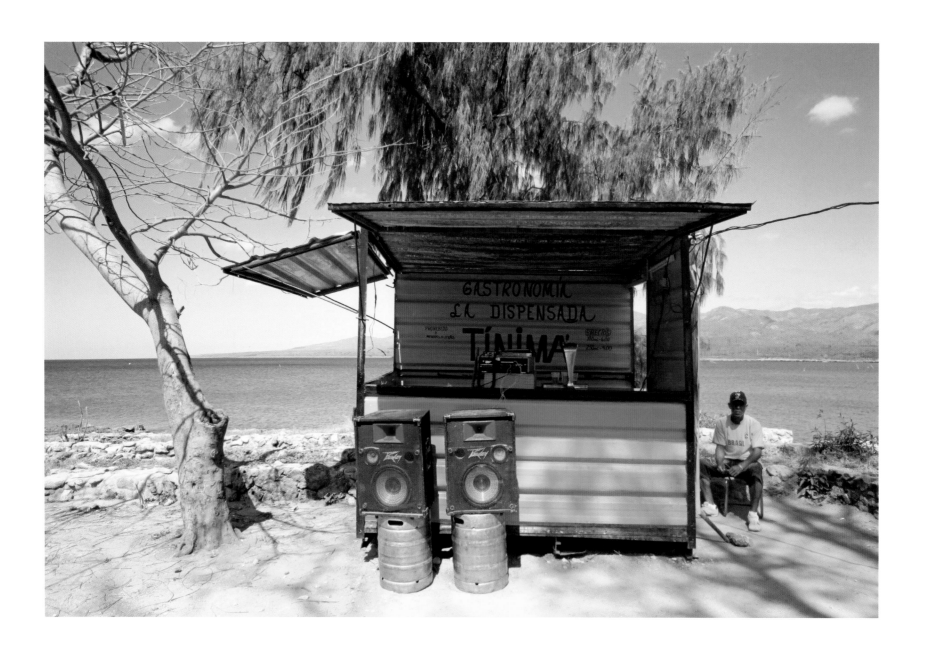

Ancon Beach—Playa Ancon is a white sand beach on a narrow peninsula, which curves eastward into the Caribbean. The Escambray Mountains are visible in the background.

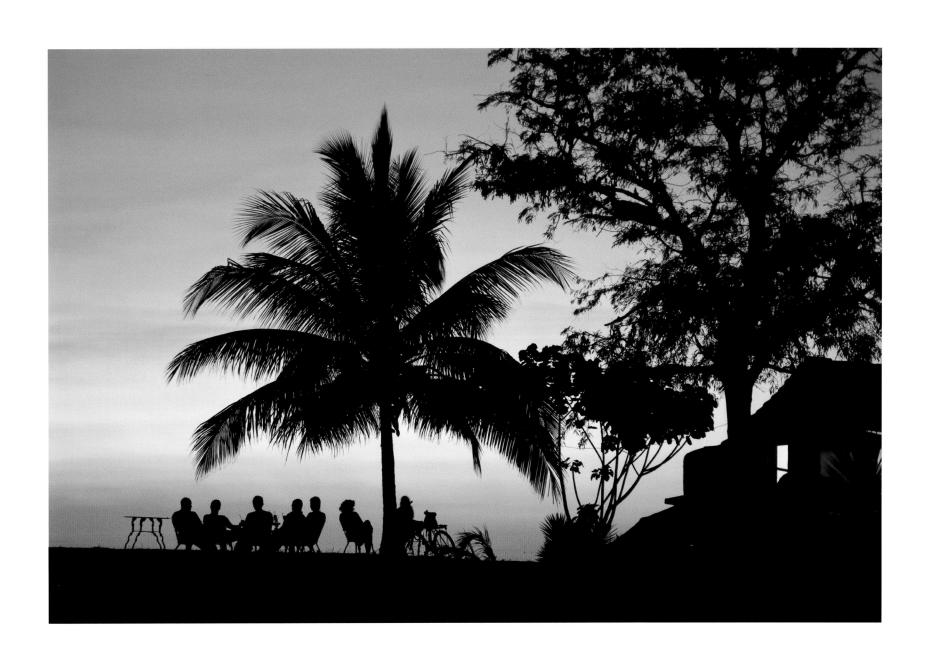

NATIONAL PARKS

Environmental protection and the maintenance of nature are taken very seriously in Cuba. Not least for this reason has the island so much amazing countryside to see.

Cuba's national parks, from the delicate wetlands at Montemar to the imposing mountains of the Sierra Maestra, protect the country's abundance of flora and fauna.

While visiting Parque Nacional La Mensura, inhale the rich pine scent in this heavily forested 5,300-hectare park south of Mayari. High above the cloud line here, the beautiful Pinares de Mayarí pine forest here is a great place for some hiking or relaxation. You can find yourself at the foot of Cuba's tallest waterfall, Salto del Guayabo.

Parque Nacional Sierra del Cristal, Cuba's oldest national park, established in 1930, is home to Holguín's highest peak, the Pico de Cristal. Hiking the mountain valleys is the most loved activity and tourists visit this national park to enjoy this thrilling adventure and experience the mountain and wild life.

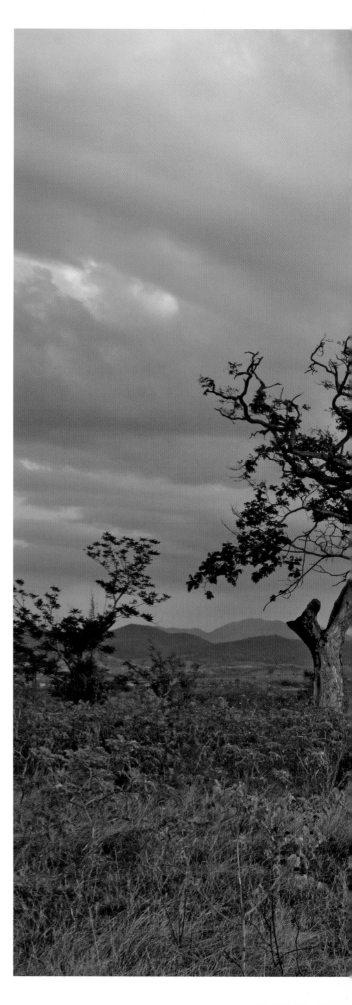

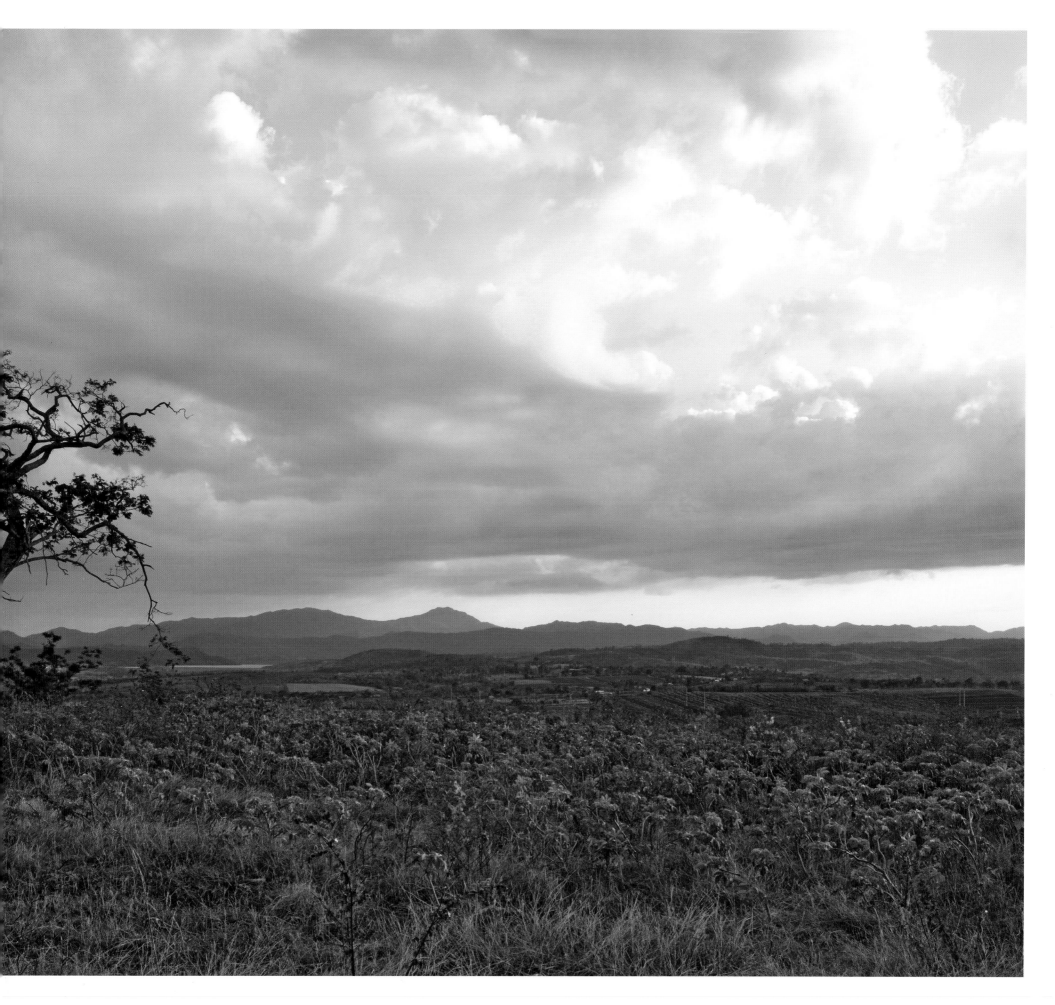

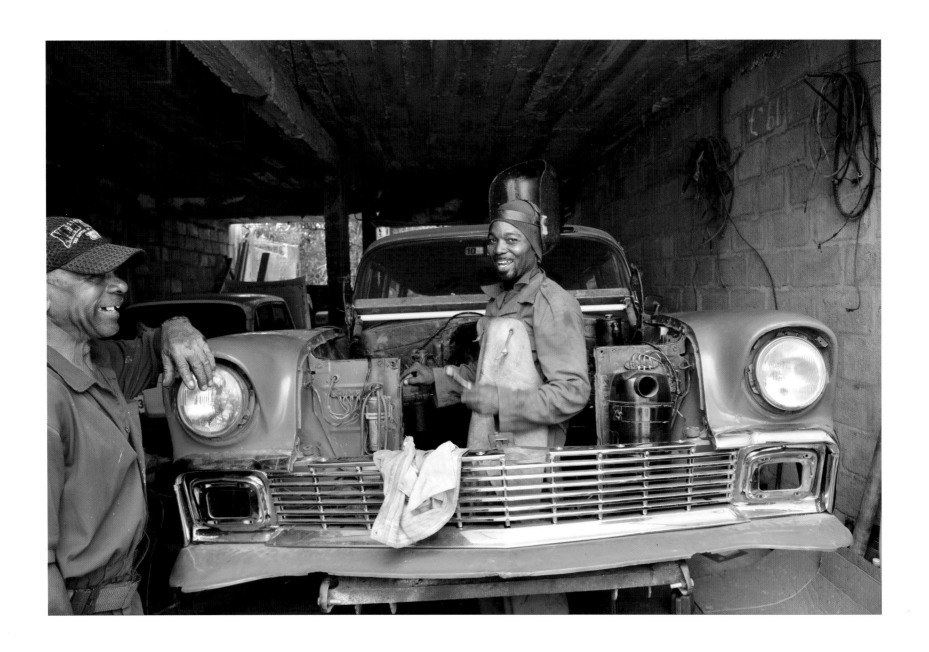

This municipality is mountainous, where it overlays the Sierra Maestra, and borders the Windward Passage of the Caribbean Sea in the south. The Guantánamo Bay is a natural harbour south of the city.

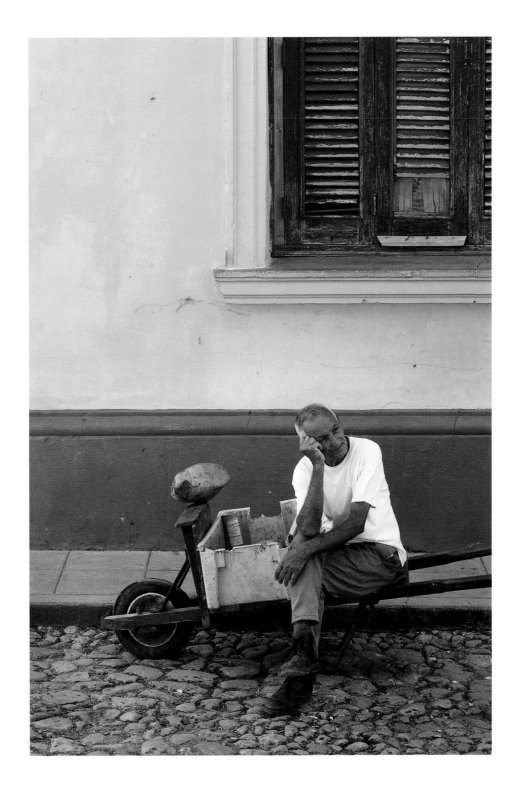

Trinidad was founded on December 23, 1514 under the name Villa de la Santísima Trinidad. It is one of the best preserved cities in the Caribbean from the time when the sugar trade was the main industry in the region.

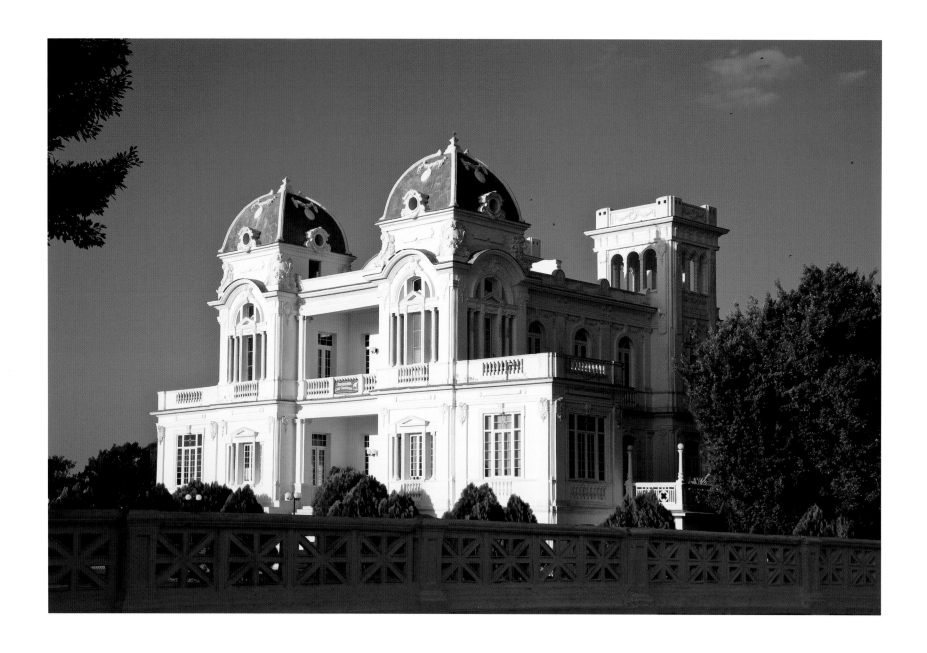

Cienfuegos is the only city in Cuba that was founded by the French. As a result, it feels a little different than other Cuban cities, with wider streets.

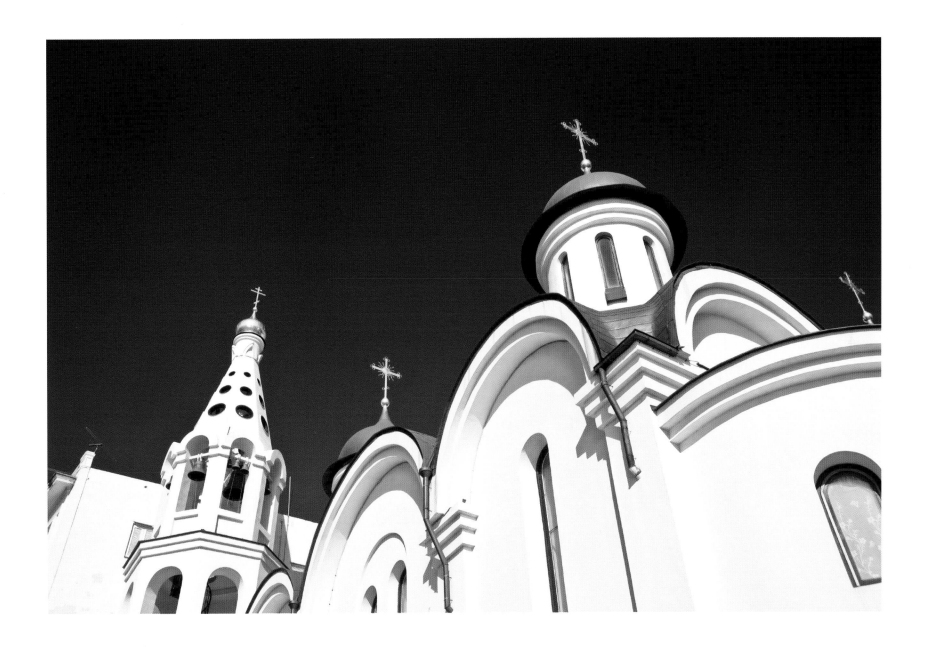

The temple was built on the shores of Havana Harbour. Built in the style of a composition of types of circular towers, the Cathedral is crowned by an imposing central golden cupola, surrounded another four smaller copper-colored ones, all the shape of an onion bulb and integrated into a Byzantine structure.

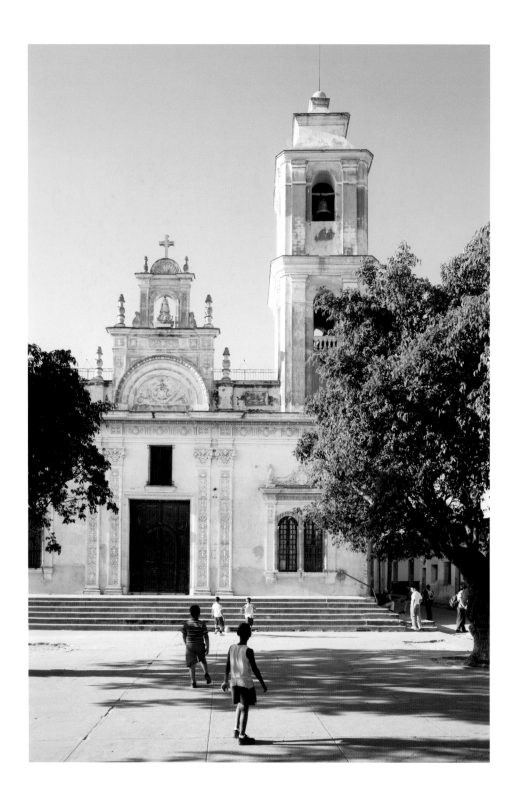

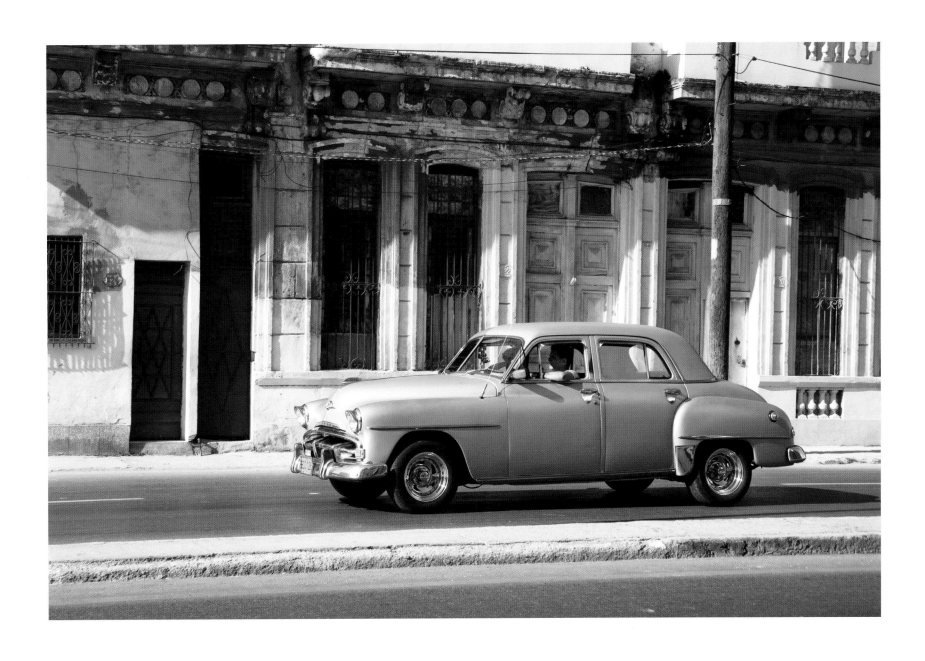

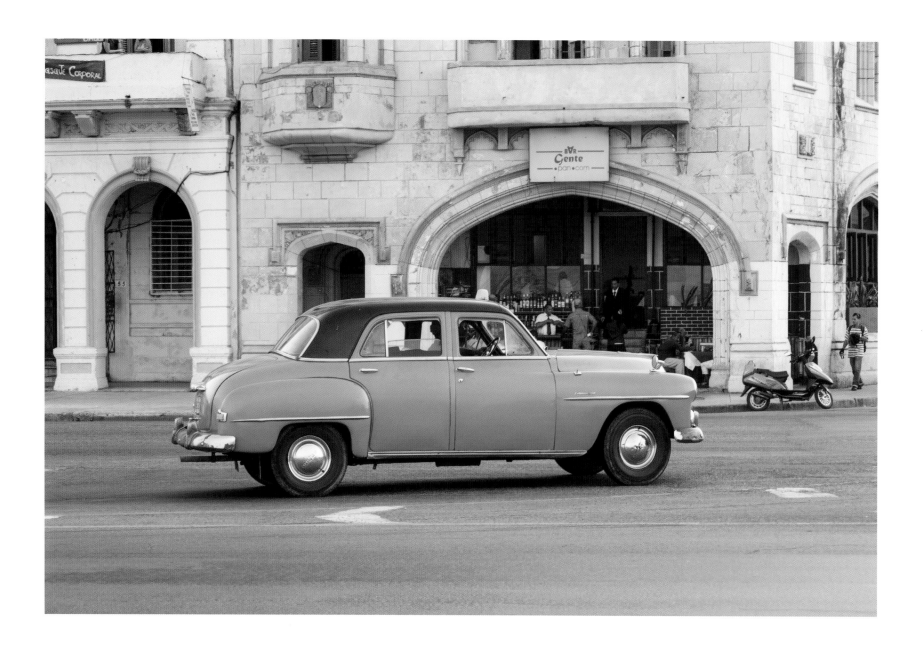

Cuba is famous for its old cars and trucks, which can be seen in daily use throughout the country. A subsequent U.S. trade embargo, instituted in October 1960 in response to Cuba's seizure of U.S.-owned properties, not only ensured that new vehicle exports would remain halted, but also denied Cuban motorists a direct source of replacement parts. As a result, Cubans became expert at adapting or fabricating parts to keep on the road cars that in other countries would long since have been recycled.

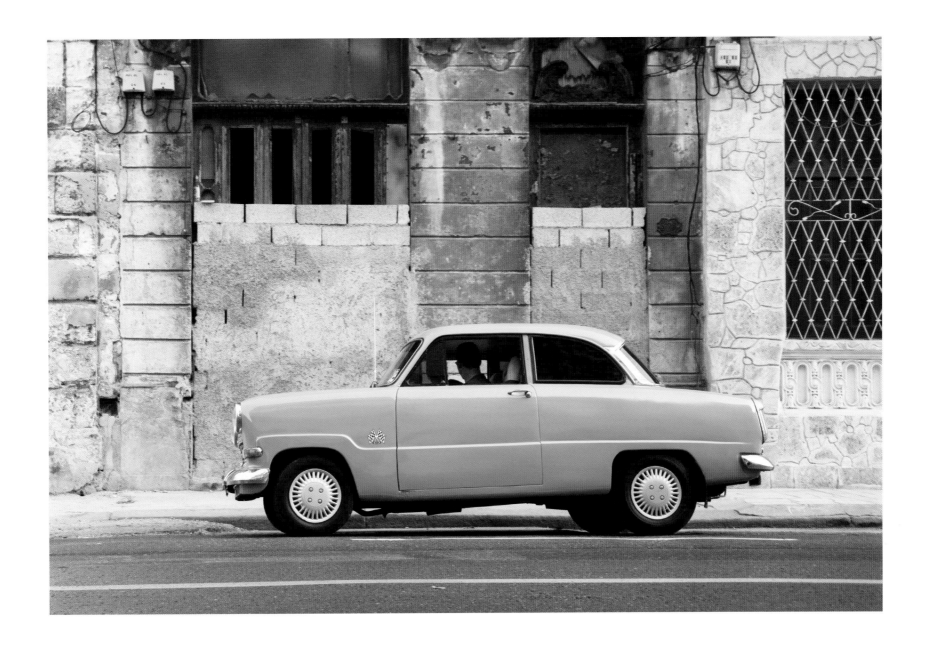

There are a lot of cars from the Soviet era.

Commander Arsenio Garcia Davila's role in the Cuban Revolution
On 2 December 1956, 82 men landed in Cuba, having sailed in the boat Granma from Tuxpan, Veracruz, ready to organize and lead a revolution. The early signs were not good for the movement. They landed in daylight, were attacked by the Cuban Air Force, and suffered numerous casualties. The landing party was split into two and wandered lost for two days, most of their supplies abandoned where they landed. They were also betrayed by their peasant guide in an ambush, which killed more of those who had landed. Batista mistakenly announced Fidel Castro's death at this point.

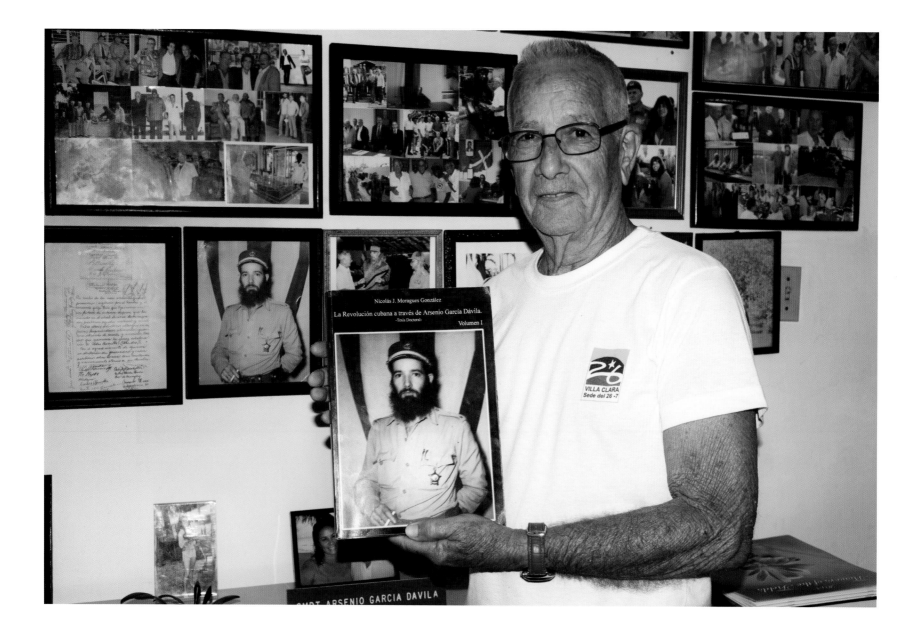

Of the 82 who sailed aboard the Granma, only 12 eventually regrouped in the Sierra Maestra mountain range. There they encountered the Cuban Army. Guevara was shot in the neck and chest during the fighting, but was not severely injured. (Guevara, who had studied medicine, continued to give first aid to other wounded guerrillas.) This was the opening phase of the war of the Cuban Revolution, which continued for the next two years. It ended in January 1959, after Batista fled Cuba for Spain, on New Year's Eve when the Movement's forces marched into Havana.

Mayor General Calixto Garcia had a long string of victories, including the taking of Tunas and Guisa, and the emotionally significant re-occupation of Bayamo. García made liberal use of spies to prepare his attack. José Martí y Zayas Bazán, son of José Martí, the major Cuban National Hero, directed artillery.

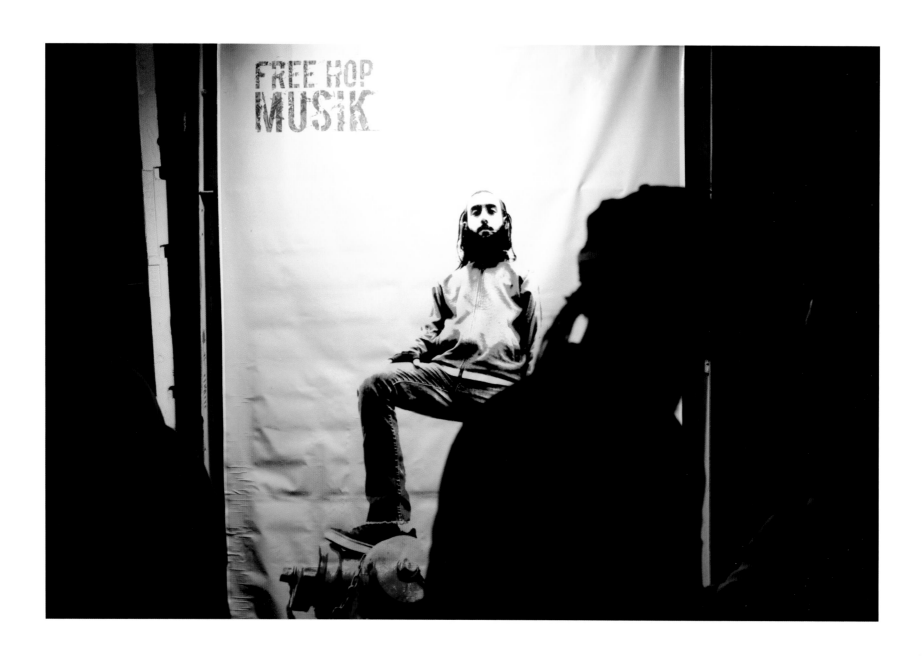

David D Omni was raised in the Alamar district, east of Havana, which according to David D, is a "young city, formed in the 1970's, as a project." Think of Chicago's south side or better yet, a more tropical version of New York City's "Nychaland."

David D'Omni, poet, musician and painter of the arts collective known as Omni Zona Franca

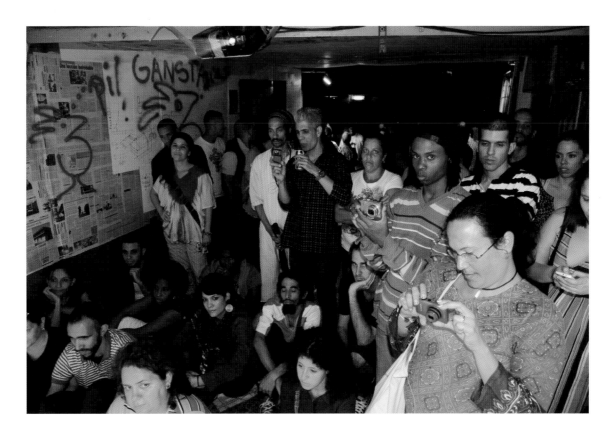

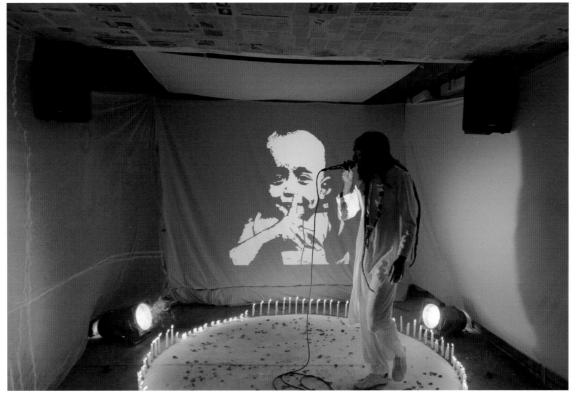

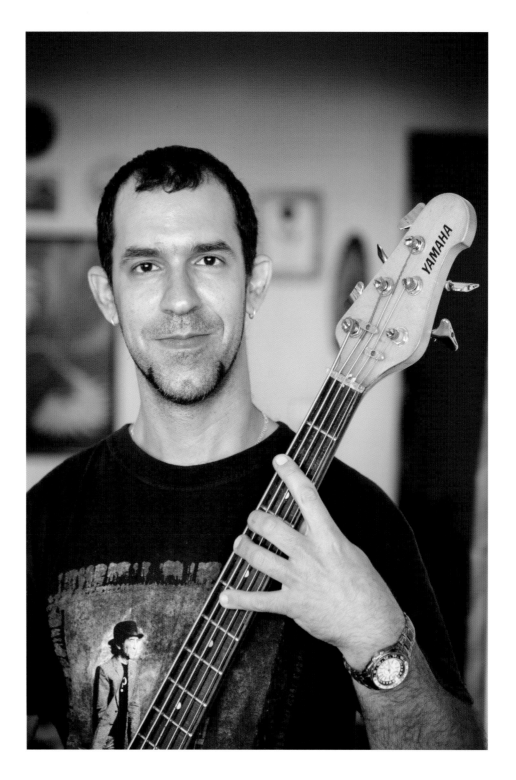

Extraño Corazón (Strange Heart), founded in 1992, is one of Cuba's most popular bands.

Changing attitudes: Rock music was heavily censored and restricted in the 1960s and 70s, but musicians continued to perform underground. It wasn't until the 60s' generation had matured that the regime was prepared to authorise performance spaces for them. Rock and jazz were seen as anti-revolutionary expressions of Anglo-Saxon culture according to journalist and Cuban music critic Joaquín Borges Triana, At the beginning of the revolution, people viewed them as ideological expressions that were harmful to the revolutionary process. In the 1980s, when the revolution was well and truly established, the authorities opened up the rock scene.

Cuban rapper Aldo Rodríguez, known in Havana's music underground as AL2 of the polemic hip-hop outfit Los Aldeanos, expertly dodges questions about the many times he's wound up in a Cuban jail for spitting searing rhymes against the establishment. "I lost count," he says matter-of-factly from his cellphone in Tampa, his new home away from home, adding that his experience was no different from the guy next to him arrested for mistaken identity or the avocado peddler caught doing business in the black market. "We're all Cuban, so que bola [what's up]," he grumbles. "None of us were happy to be there."
by Lissette Corsa

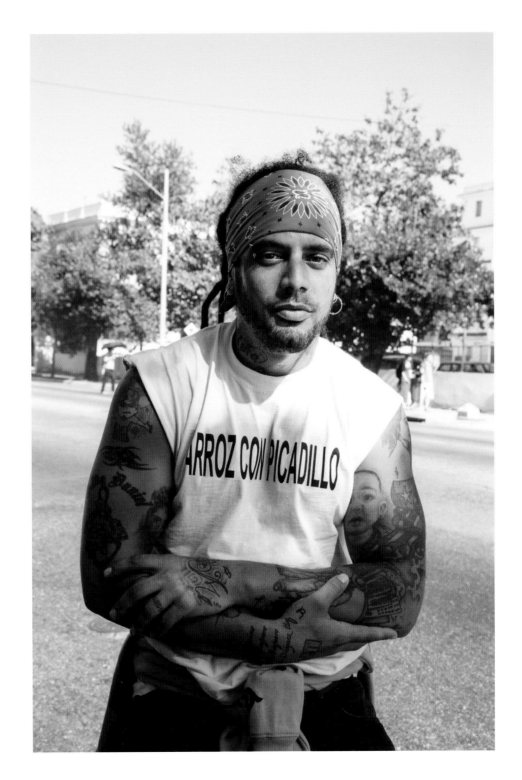

Danay Suarez can rap convincingly about the plight of sisters and the shortcomings of brothers without striking a gangsta pose, and her singing is invariably lovely. Commenting on "Espinita," one of her songs available on YouTube, a Danay fan describes her as "the representative of conscious female Cuban hip-hop with the most exquisite voice and the most intelligent lyrics," and anyone who has been lucky enough to watch her perform in Havana is likely to agree.

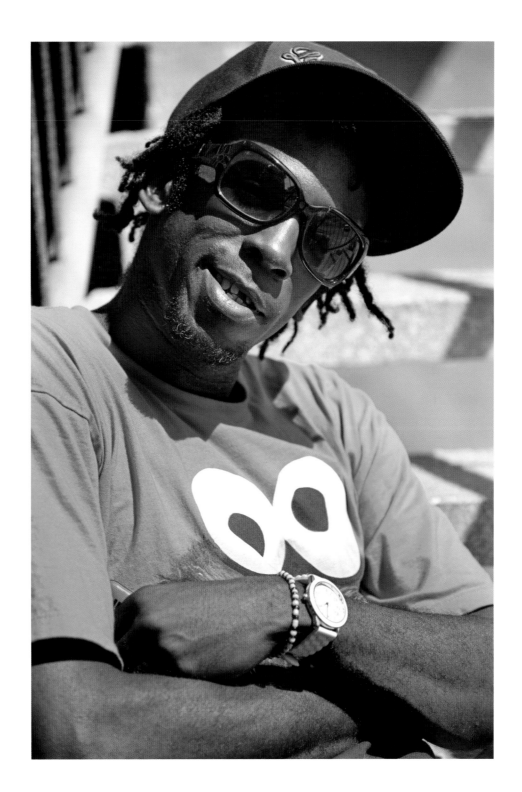

Etian the "Brebaje Man," he has
a strong on-stage projection as a
poet of today's times. His manner
of speaking is direct while his words
are colored by personal experiences,
which is why he's followed by a
public that always expects depth in
his messages for reflecting, learning
and enjoying.
by Helson Hernandez

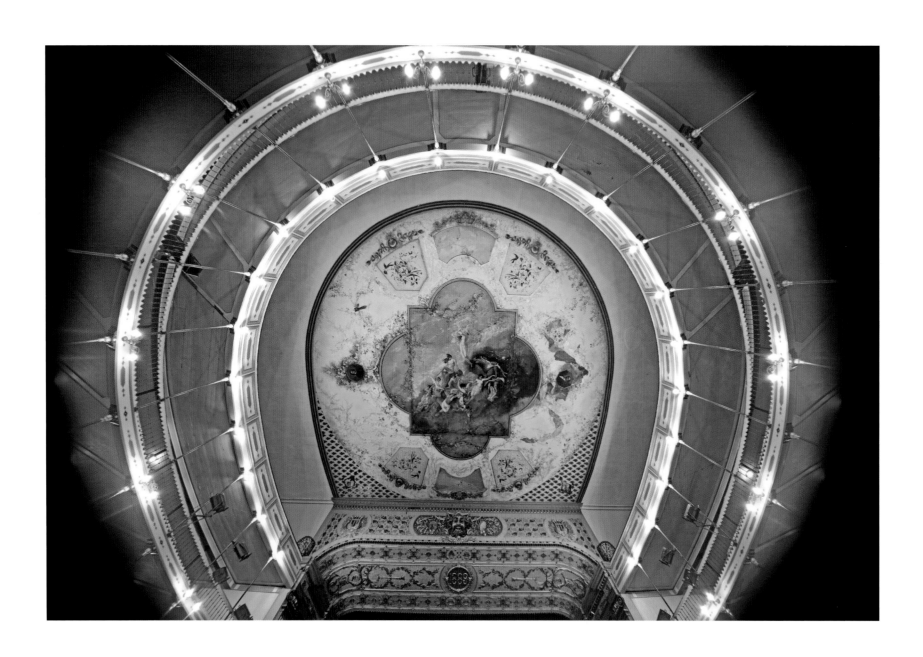

Ceiling adorned with an exquisite painted mural.

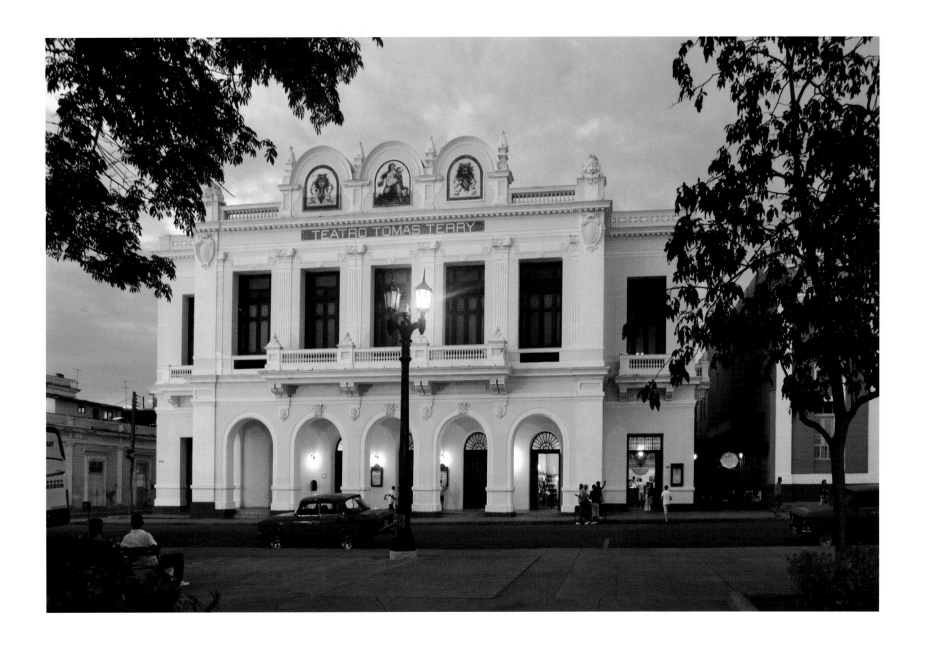

Tomás Terry Theater, is one of the finest eclectic buildings of the city of Cienfuegos. This Italian looking theatre was the creation of architect Lino Sanchez Marmol and was built in 1889. The two story theater has five arches on the ground level to mark each entrance, while the second level displays square window and a small central balcony. The interior of the building, which can hold up to 950 people.

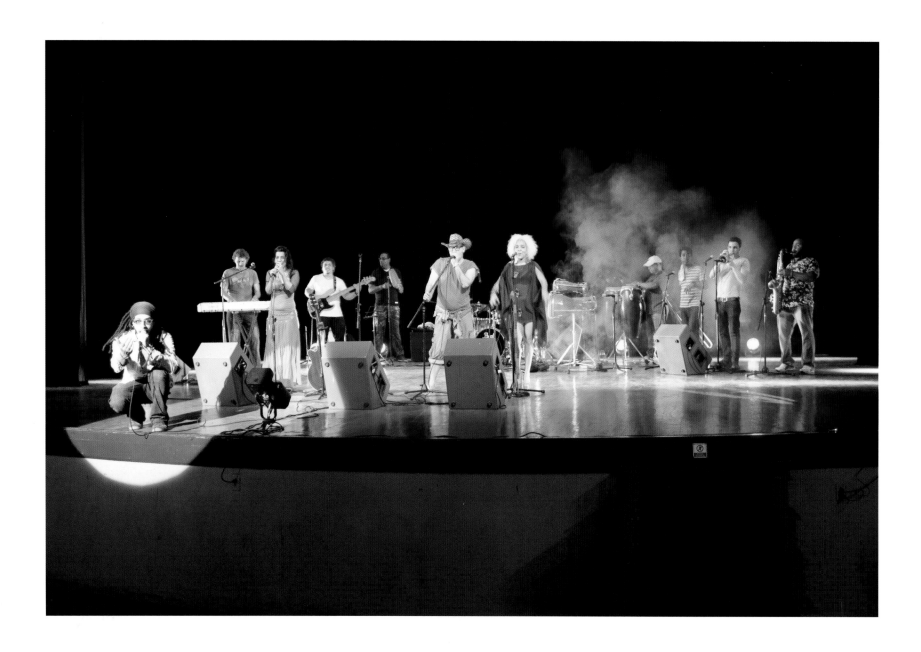

Interactivo plays a blend of timba, the high energy Cuban style of salsa, and novísima trova, the latest incarnation of Cuban style troubadour songs, with funk, jazz, R&B and hip-hop. As an acknowledgement of their growing notoriety, the band has been the subject of a documentary directed by Tane Martinez, and premiered at the Havana International Film Festival in December 2010.

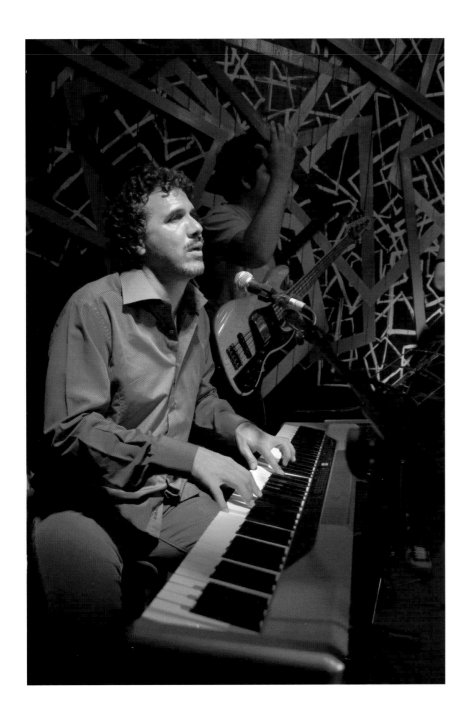

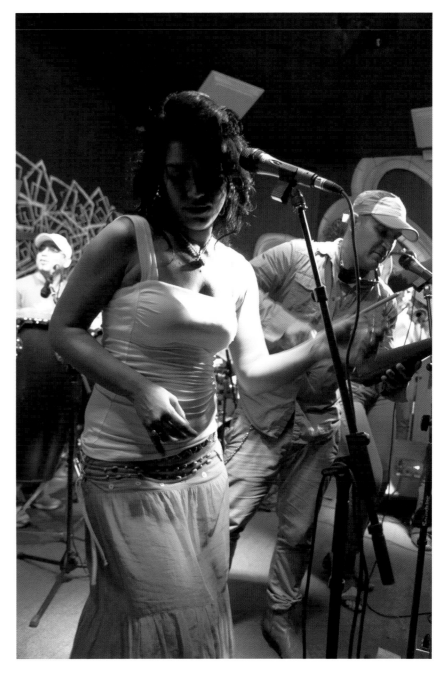

Band Leader Robertico Carcasses is a Cuban jazz pianist. He has collaborated with many musicians, such as Chucho Valdes, Chanquito, Wynton Marsalis, George Benson, and Descemer Bueno. Tanmy Lopez on the right.

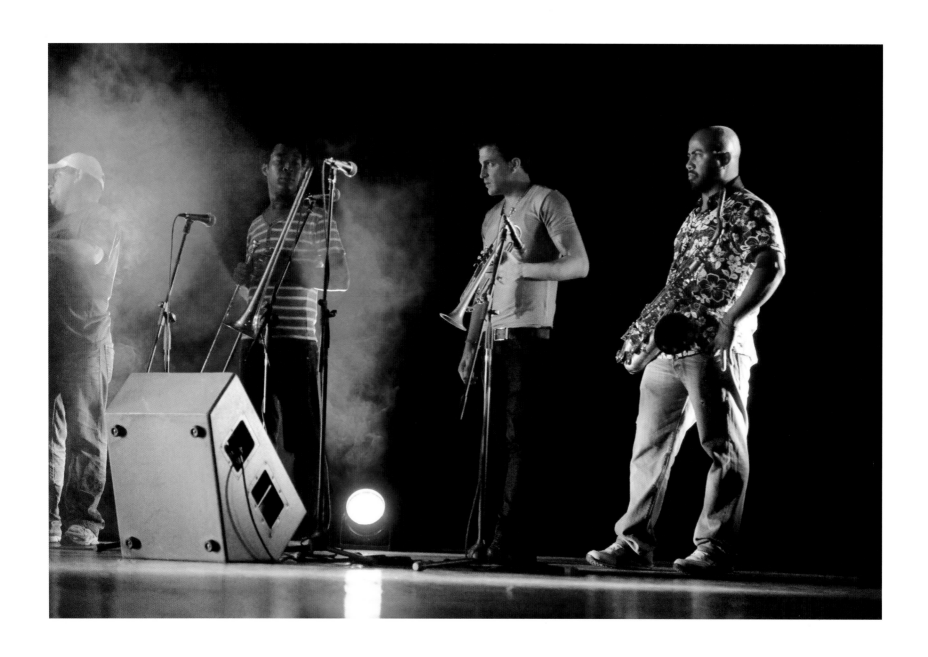

"Panga" (percussionist), Juan Carlos (trombone), Alejandro (trumpet), Millares (sax).

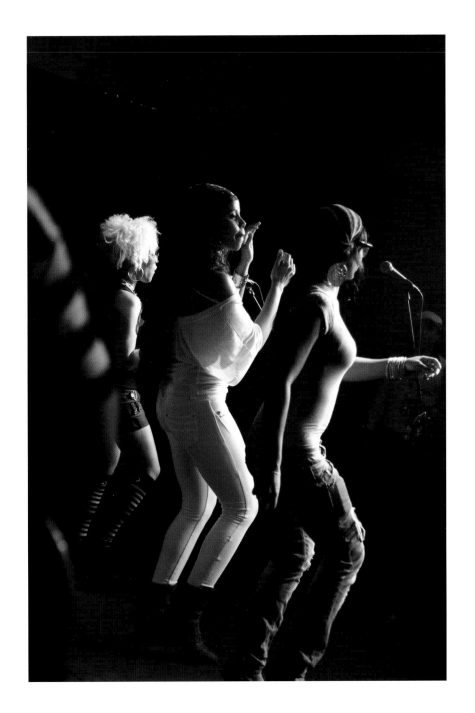

Haydee Lopez (vocals and flute), Melvis Estevez (vocals),
Brenda Navarrete (vocals).

William Vivanco (vocals, guitar, composer).

Francis del Rio (vocals, composer). Leads a band called IFA.

Juan Carlos Marin, El trombon de Santa Amalia, (trombone, composer).

Melvis Estevez (vocals and film actress).

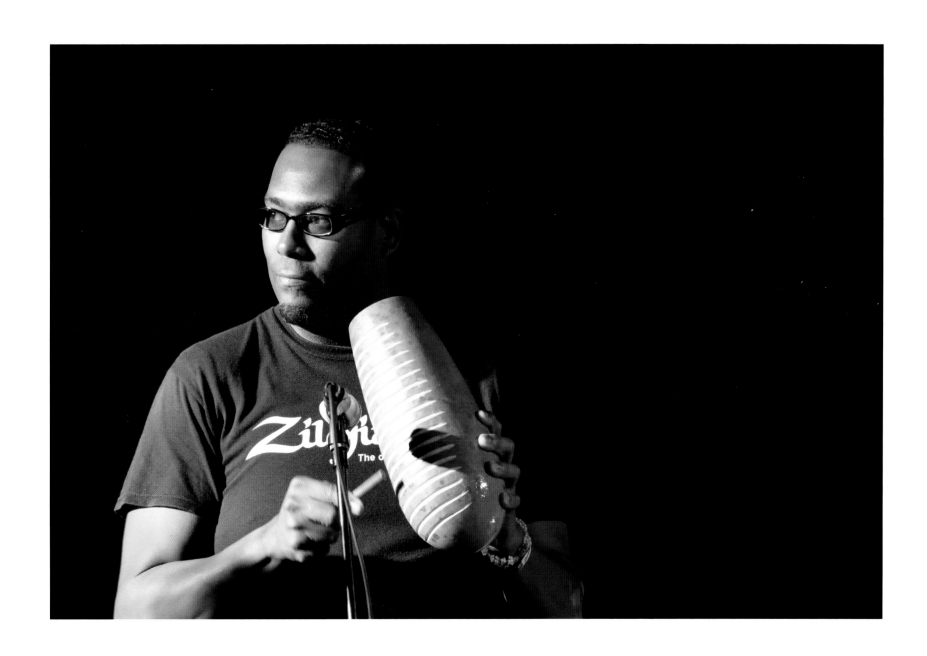

Boris Castellanos (percussionist, guiro).

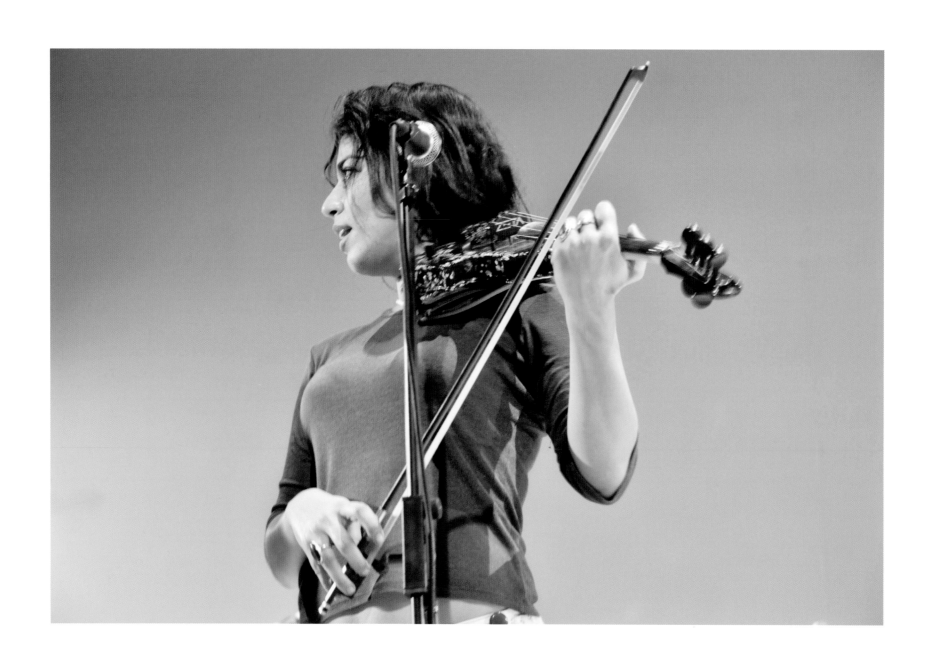

Tanmy Lopez (violin, singer, composer). She leads a band called PURA CEPA.

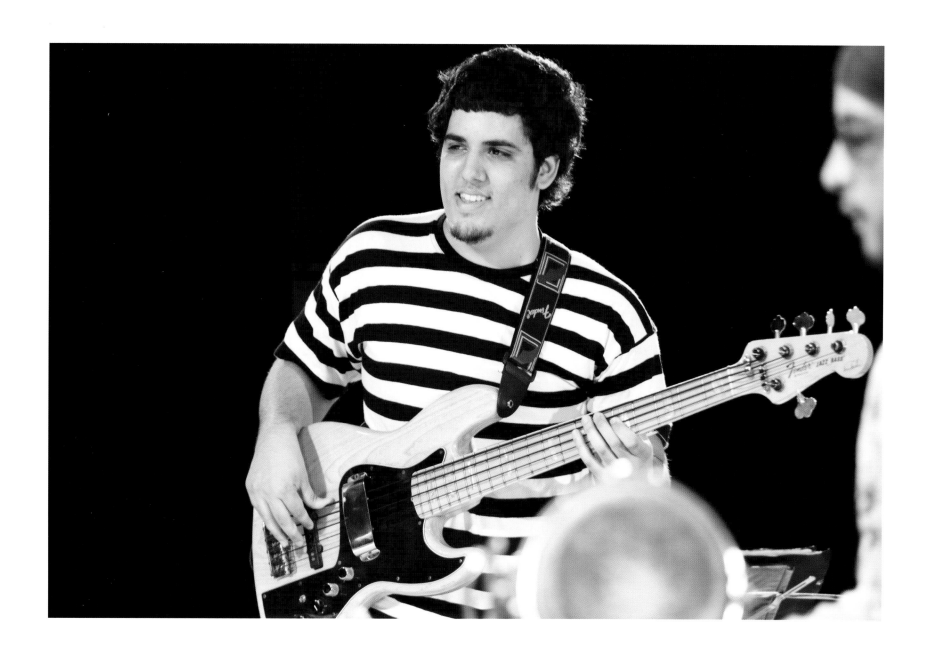

Carlos Rios (bass).

THANK YOU

A special thank you goes out to everyone involved with this project for their knowledge, consideration, contributions, generosity and friendship.

Ileana Rodriguez

John and Titi Yingling

Robertico Carcasses

Tammy Lopez

Adem Rodriguez Garcia

Carlos Millares

Bernie Couris

Gail Fields

Arsenio Garcia Davila

Rowland Scherman

Omar Pérez

Etian (Brebaje Man)

Orlando Mendez Montero

Rolando Llaver de Leon

Alexander Guerra Figueredo

Adelaida Garcia

Norma Perez y Arcia

Magaly Rodriguez

Eloy Acosta y Sonia Perez

Kristin Dykstra

Jose A. Peralta y Dulce Peiso

Maxiamo Family

Angel Quentin Rodriguez

Melissa Yeaw

Loreen Bosse